Contributors

Allen Egan
Jim Boring
Adam Caldwell
Nathan Filbert
Jennifer Koe
Grace Cavalieri
Timothy Brainard
Marcus Slease
Laurie Kolp
Amy Serrano
Bill Yarrow
Annie Terrazzo
Howard Camner
Eileen Tabios
Veronica Coulston
Hesther van Doornum
Stacey Waite

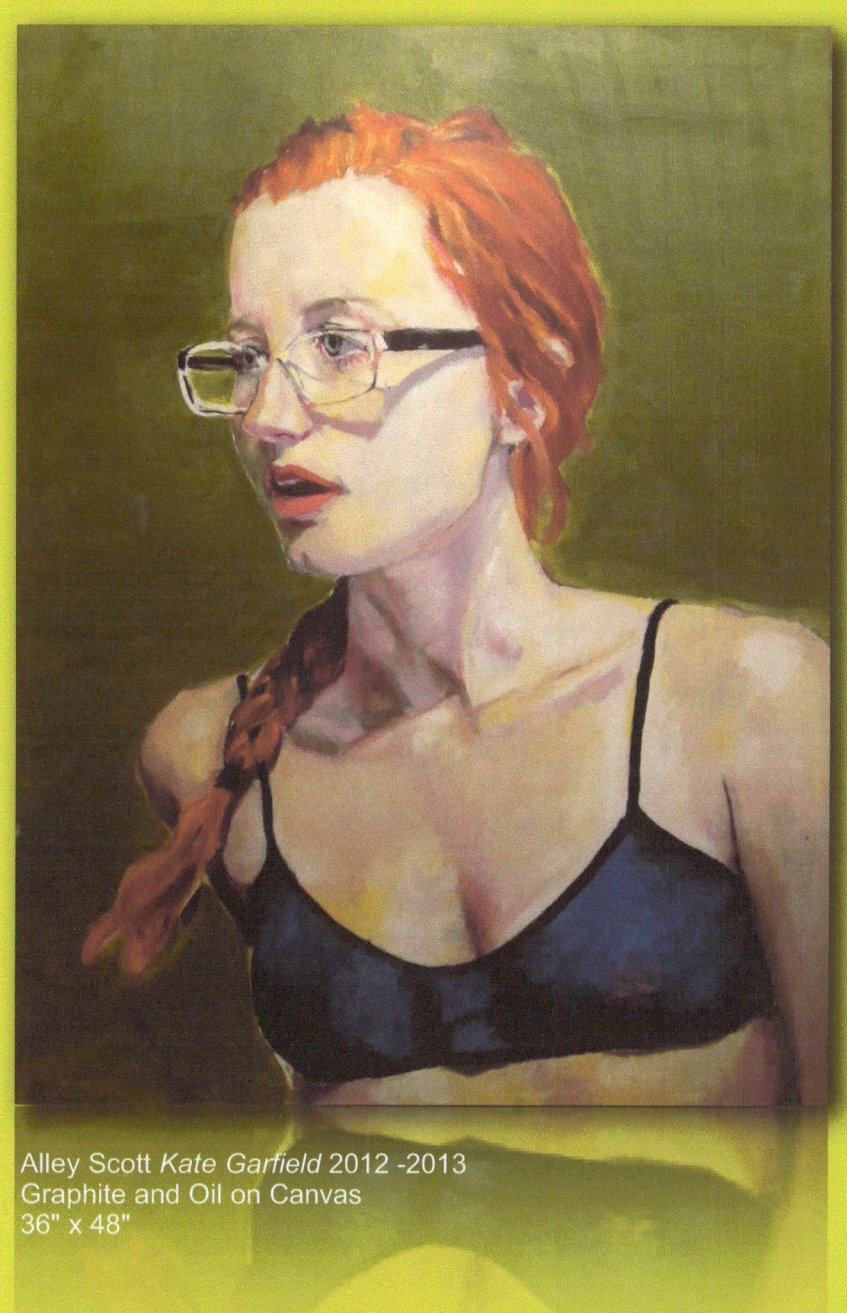

Alley Scott *Kate Garfield* 2012 -2013
Graphite and Oil on Canvas
36" x 48"

Cover Artist

Alley Scott is an actress and artist who has lived in New York City since 2004. An artist model since that time, she is interested in the blurred line between the subject and the artist, and the shared responsibility of collaboration on a piece of figurative work.

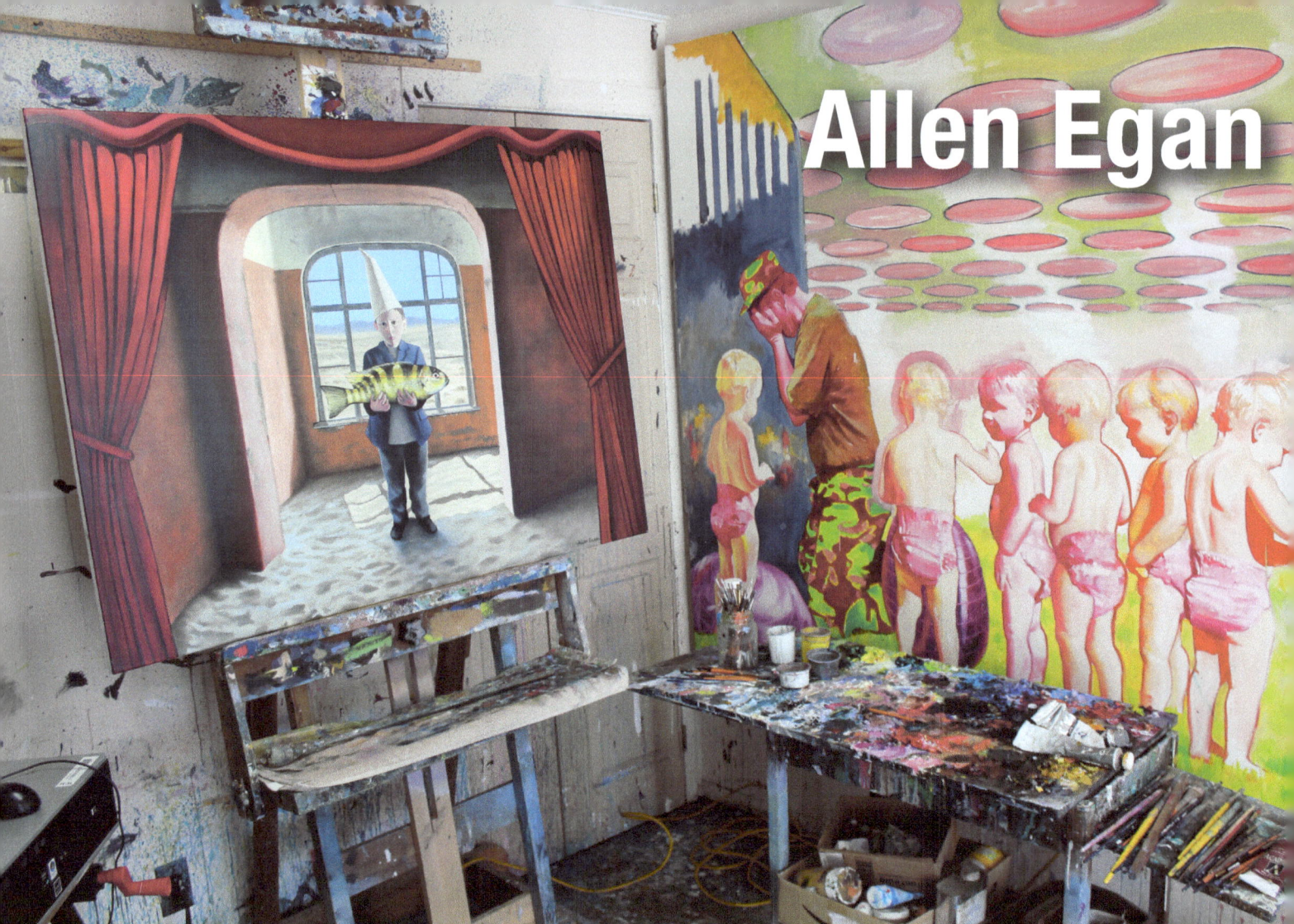

Allen Egan

Allen Egan was born and raised in Rhodesia (Zimbabwe) and started painting in oils at the age of 16.

After high school he completed a 3-year graphic design course at college and worked in the print and graphic design industry until 1989 when he immigrated to South Africa.

For several years Allen owned and operated printing and manufacturing businesses in South Africa before he began painting and exhibiting fulltime. At this time Allen began to document and paint African people in their rural environments.

Allen immigrated for a third time in 2000 - this time to Canada, eventually settling in Gatineau (Quebec). He continued to paint African people for a few years, traveling back and forth to South Africa to exhibit paintings with galleries there and to travel into the rural areas of Southern Africa to gather photographic material.

Over the years Allen has continued to paint people but in a more contemporary manner. However and more recently, he has begun painting the Canadian landscape, specifically the region in which he lives. Painting both disciplines of figure and the landscape, contemporary and traditional helps Allen to explore, discover and improve other aspects of his talents.

Allen is a self - taught painter and paints from his studio in Gatineau.

Allen Egan

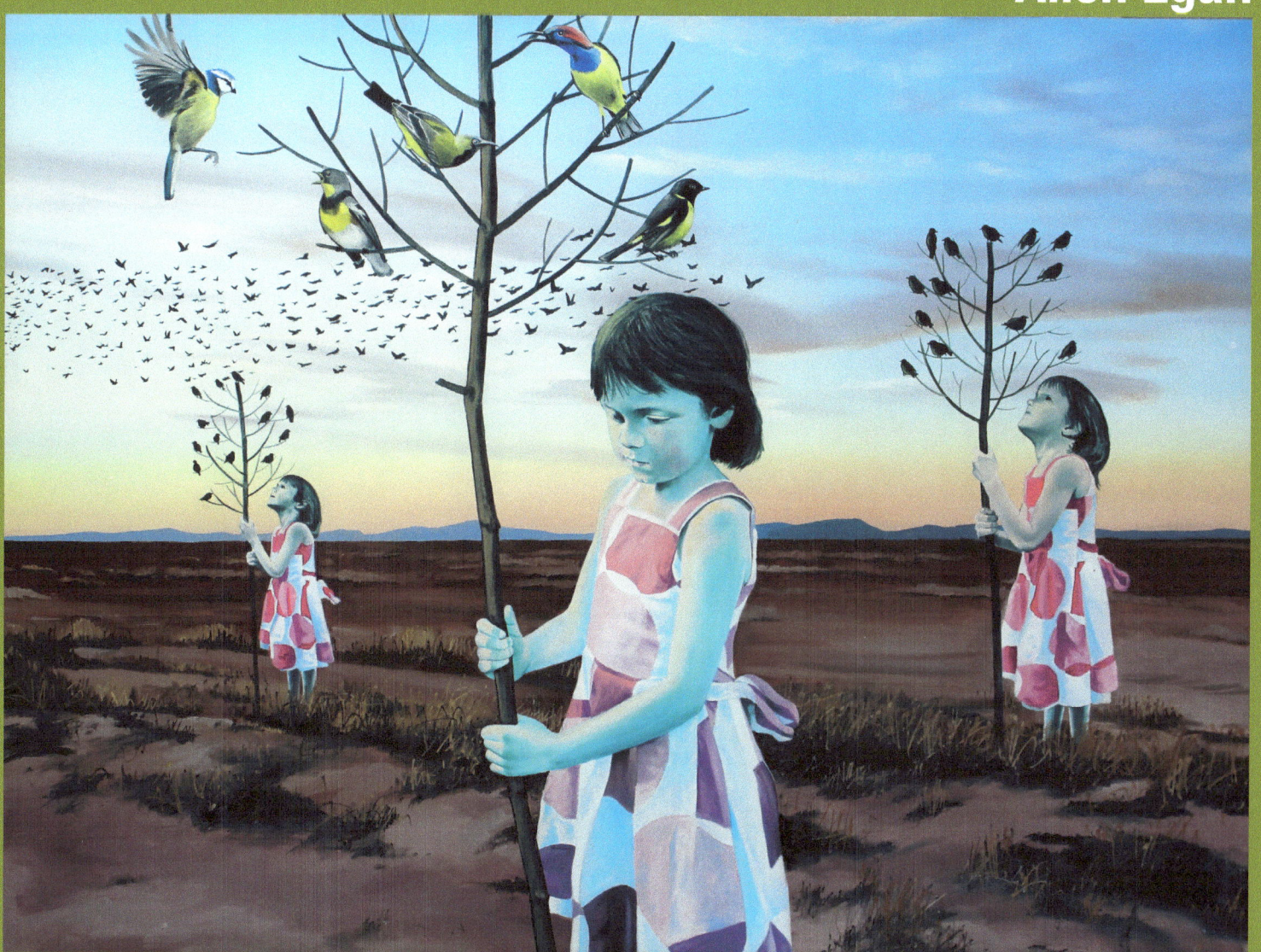

These works continue my tradition of exploring the human figure in a variety of guises and environments. In past paintings I have almost exclusively painted myself in similar environments but in this series, however, I have chosen to use my children as my models. My mandate for this series of works was to use my children as serious painterly subject matter, whilst attempting to avoid the possibility that they may appear kitsch. I did this by using an illustrative approach to my technique as well as using simple props and painting them in wild and remote places to give a sense of mystery and emotion.

It is my habit to avoid paintings that are layered with political meaning but rather to make paintings that are impulsive and spontaneous. They are not charged with any specific political motive but rather they are intended to give the viewer the opportunity to decide for themselves the potential stories that the paintings evoke. They are like a single frame in a movie. One does not know what came before and likewise one does not know what the outcome may be. They are short stories.

Allen Egan

Allen Egan

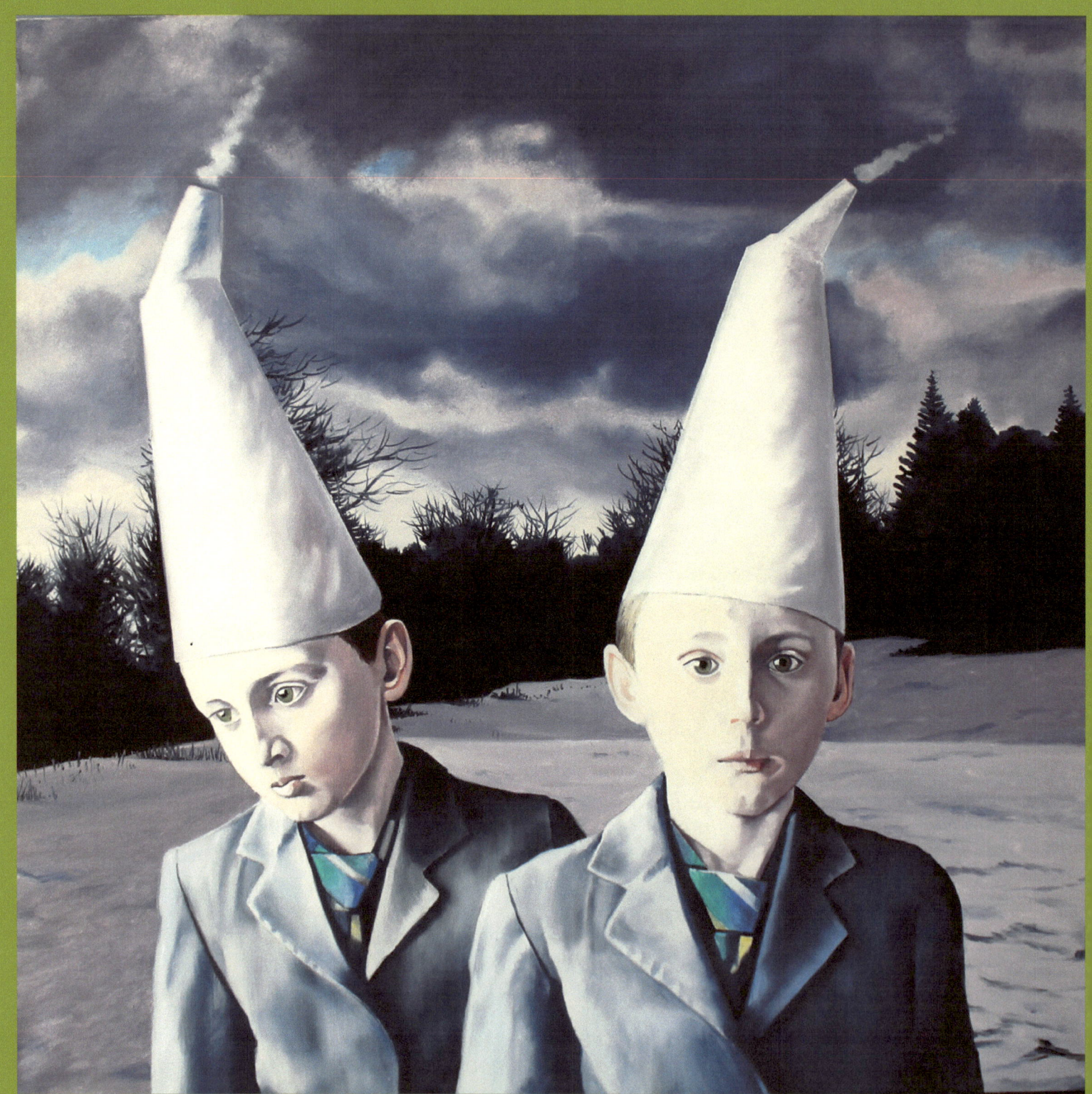

Thinking Caps oil on canvas 30x30 inches

Allen Egan

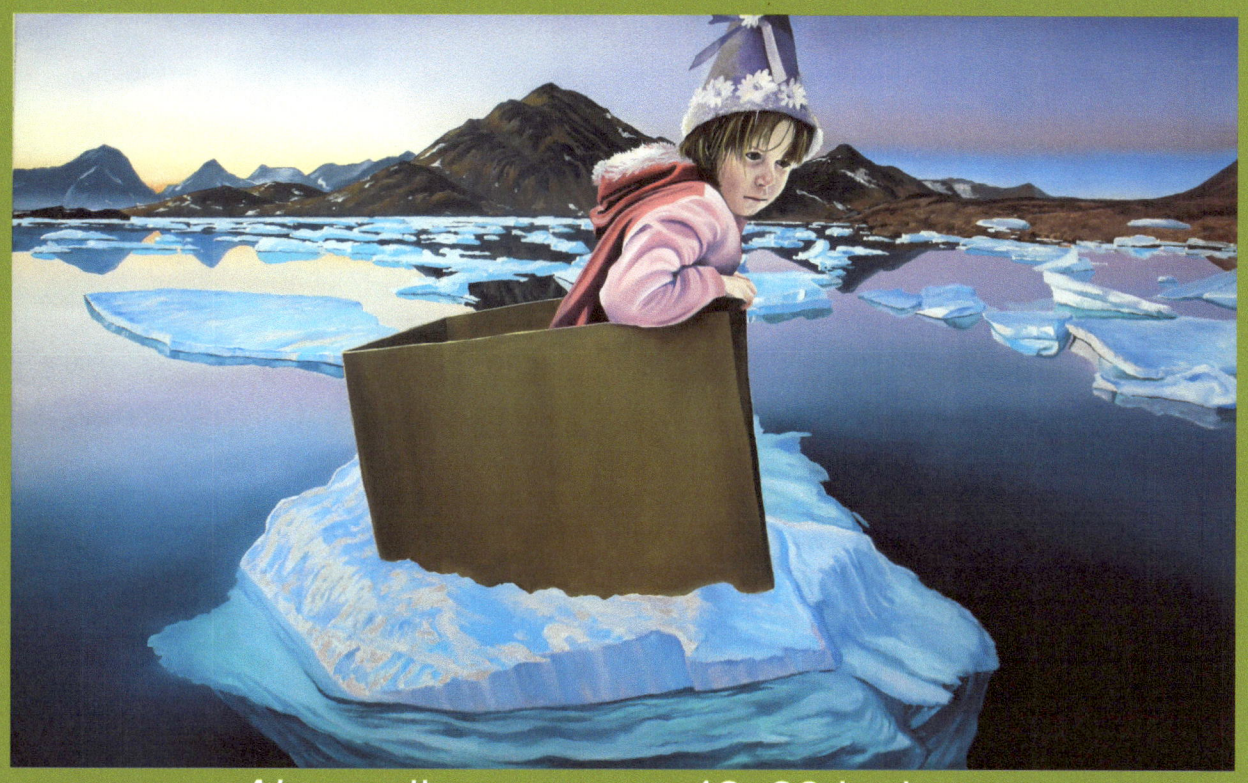

Three Sailors oil on canvas 40x30 inches

Alone oil on canvas 40x30 inches

Irish Cream

The water first with the scent of bog, the grain
breathing out its power in casks while time
mutes wildness and innocence distills to purity.
All in this little glass, this cup of kindness, this balm.

But women are not deceived and know at once
what dark energy is in the glass and how the men
will talk around the fire and smoke and sing sad songs,
how they will paw the earth and rage and strike.

On the fringe the women laugh or weep,
sing songs of hope and desire, dance together,
shake heads or hips, dart smiling into the light
or hide in terror and imagine civilization.

And this is how, my son, that now in our time
milk has been added to whisky and how your mother
and her kind won the battle for men's souls.

Jim Boring's poetry has appeared in many journals, anthologies and online venues including *PoetsArtists* and MiPOesia. His book-length poem, Condo, (Lit Pot Press, 2006), explores aging and loss in a South Florida retirement community. He is co-author of The Horse Adjutant: A Boy's Life in the Holocaust (Shooster Publishing, 2011), and author of Scraps, a novel of Chicago, in manuscript.

Adam Caldwell

Theory of Forms oils on canvas 24x30

Adam Caldwell is seeking out a way to keep a consistency and at the same time leave his paintings open ended. Although he has explored various techniques he never wanted a style that would limit his work.

He starts with a concept that stems from his interests in politics, history, literature, and philosophy. Spending a lot of time reading and researching a concept he sketches out possible compositions and themes trying out ideas, rejecting synthesizing. He then finds a reference image by searching the internet, magazines, old photography books and other reference materials sometimes setting up a photo shoot having the models pose in a way that might work with the concept. He explores further by combining images in Photoshop or using traditional collage techniques. He is not trying to illustrate the ideas he has been developing. He is thinking purely in terms of composition, color, depth, movement. The idea should percolate through the image in an indirect way.

He combines flat imagery, extreme depth, realistic figuration, abstraction. When placed against each other these figures create problems leaving the viewer with a feeling of timelessness. Lasting. Tension.

INTERVIEW: Adam Caldwell

Adam do you feel your work falls an specific movement or style?

There is a current surge of figurative art that merges traditional realist skills with various other aspects or styles of painting. I tend towards blending the figure with collaged spaces and abstract brush work. I use different types and layers of photos as the basis for the composition.

I see that historical figures come into play with your work. Are you looking for a discovery from the past?

I am trying to create a layered feel. Maybe as if the place is remembering flashes from its own past. Time is definitely one of the directions I am trying to push into depth, as well as space and narrative.

As an artist how do you define success?
If I can sell enough paintings to keep working. I guess I really felt successful when my teacher and mentor Barron Storey, whose work I respect and love, came to a solo show and liked my work. I felt like I had arrived somewhere and was not a fraud.

What do you do when you are not painting?
I read a lot, I train and teach martial arts, and I play music.

Do you have any pieces that you would never consider selling?
No. I would love to have a completely empty studio. I feel encumbered by all the old work I have, it is unnecessary baggage.

What are you working on right this second?
I am working on a piece for a show at Thinkspace Gallery in July. The show is called *Reflections of a New Generation*, it opens on Saturday July 13th.

Ask yourself a question and answer it. What makes a "good" artist?
When his chosen medium and his skill are sufficient and necessary to communicate his vision or his idea.

Adam Caldwell

Science of the Mind oil on canvas 48x72

Rationality oil on canvas 48x72

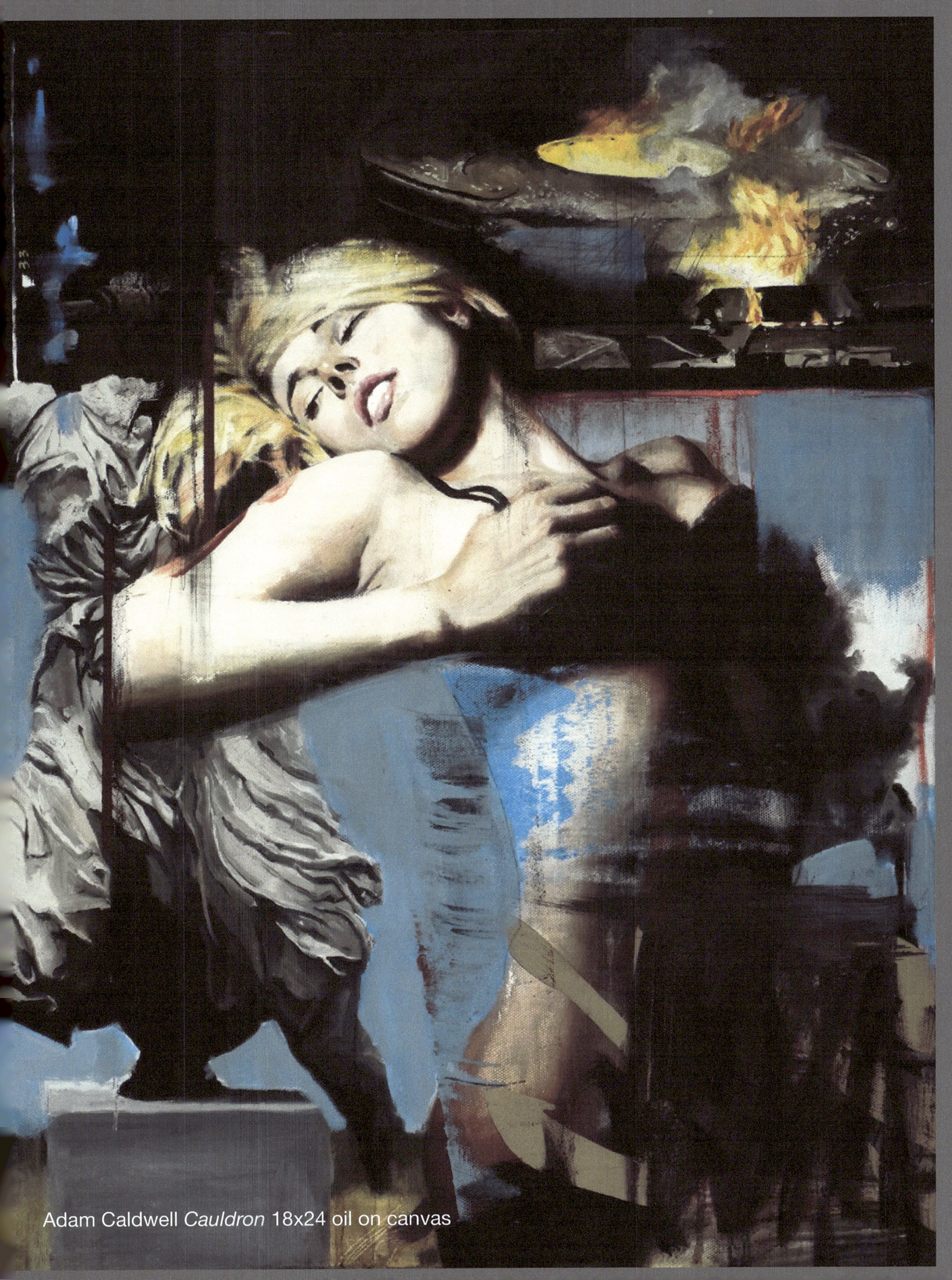

Adam Caldwell *Cauldron* 18x24 oil on canvas

OUR VEGETAL NATURE

Poems by Nathan Filbert
Photography by Jennifer Koe

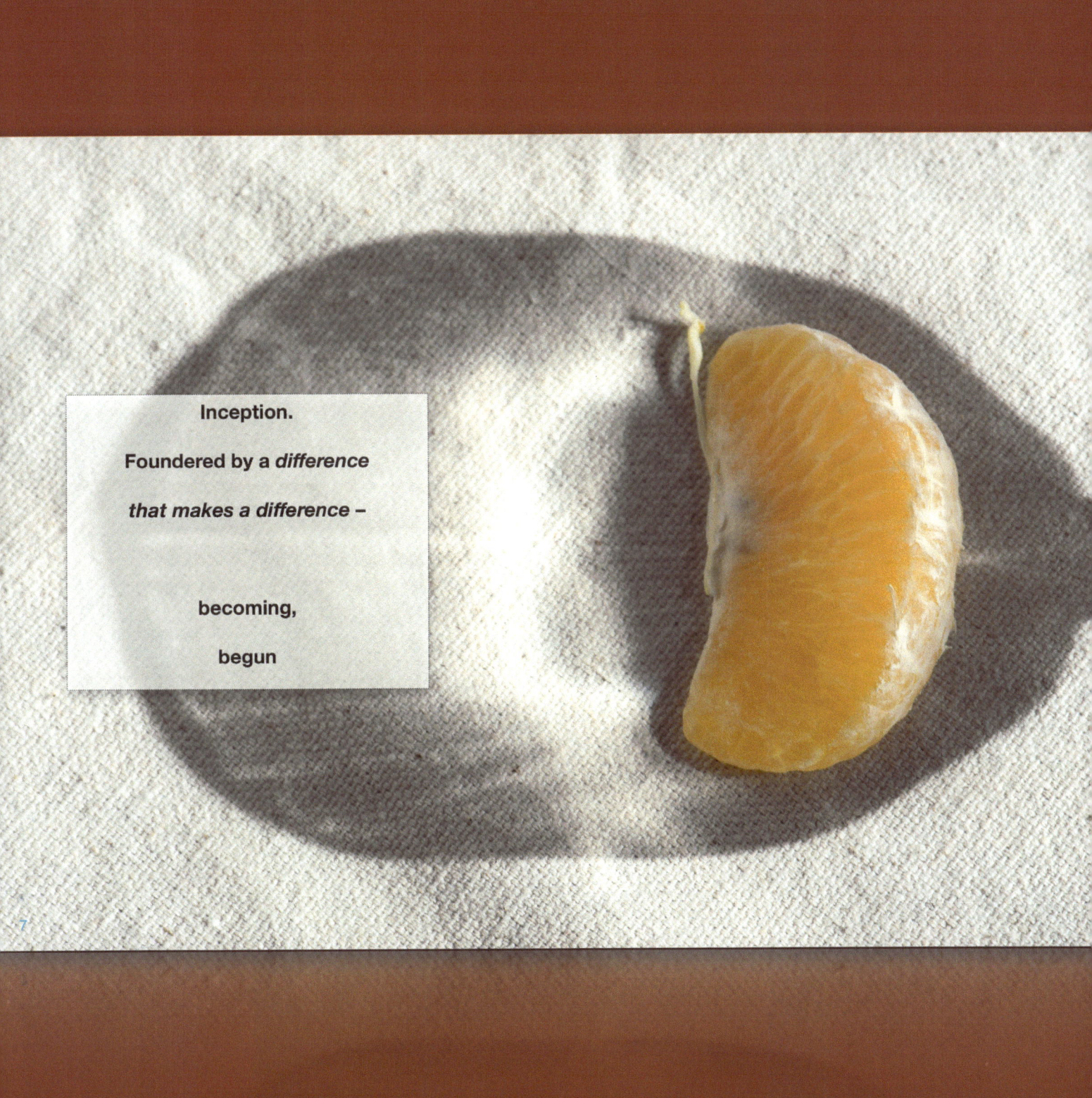

Inception.

Foundered by a *difference*

that makes a difference –

becoming,

begun

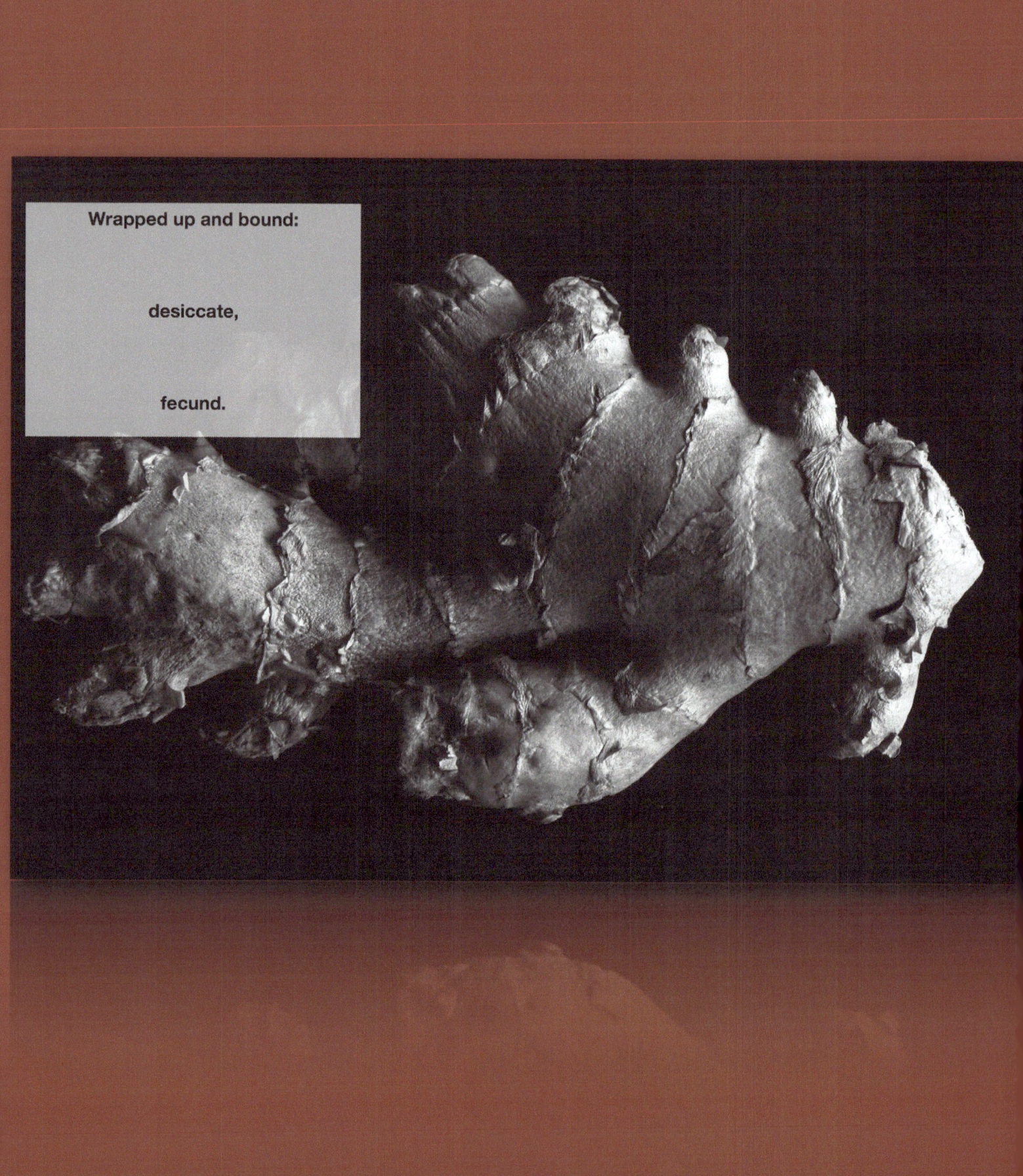

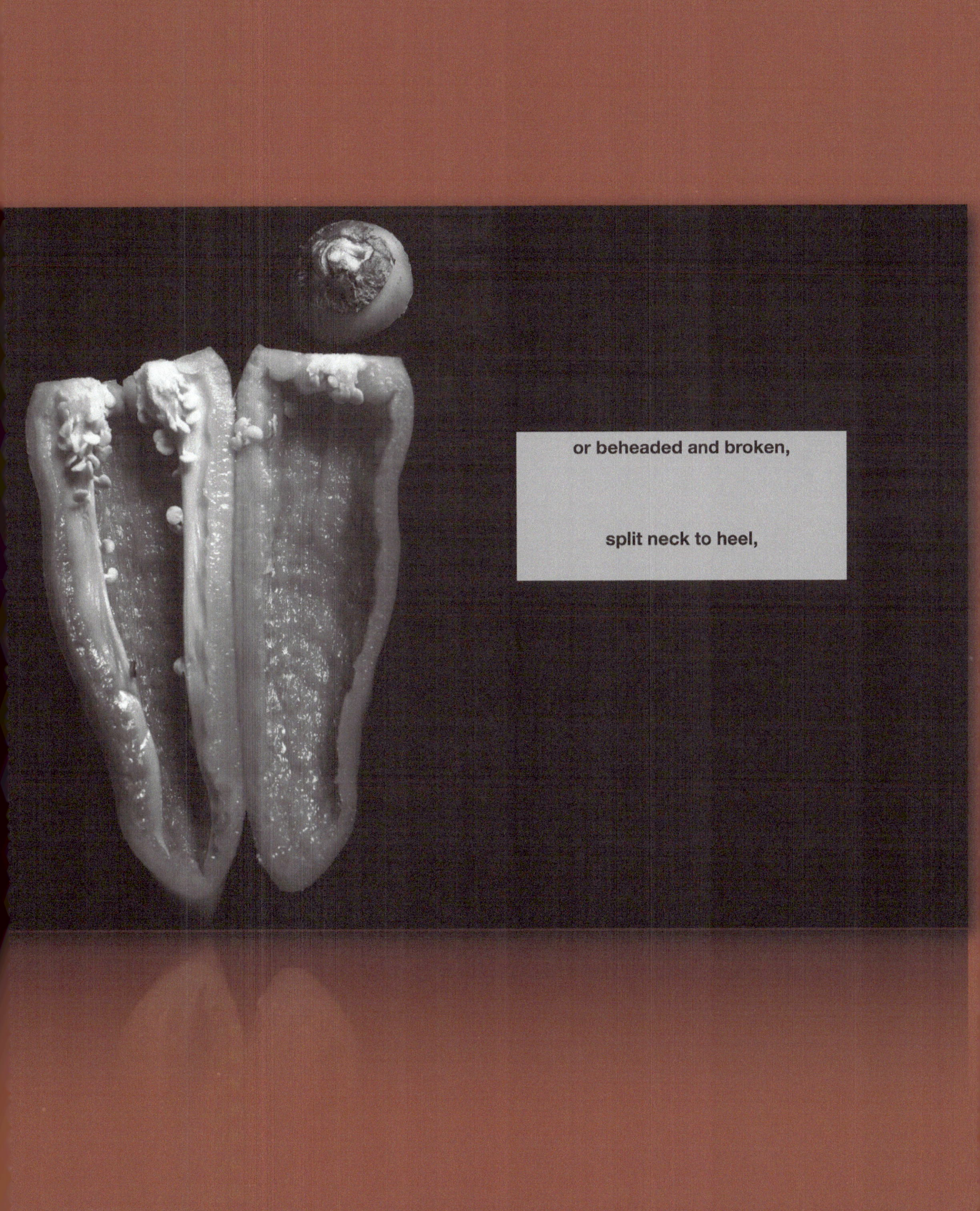

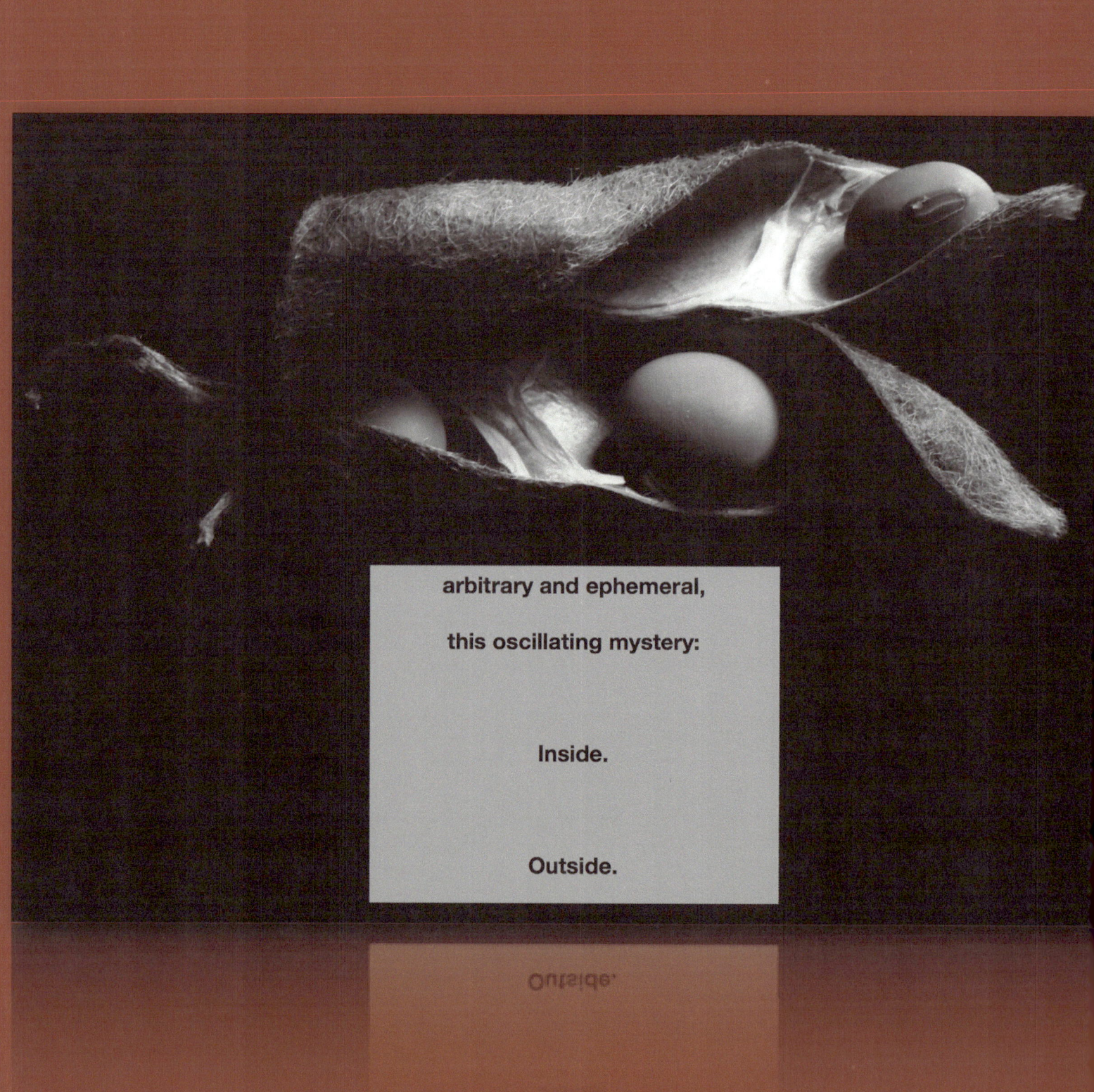

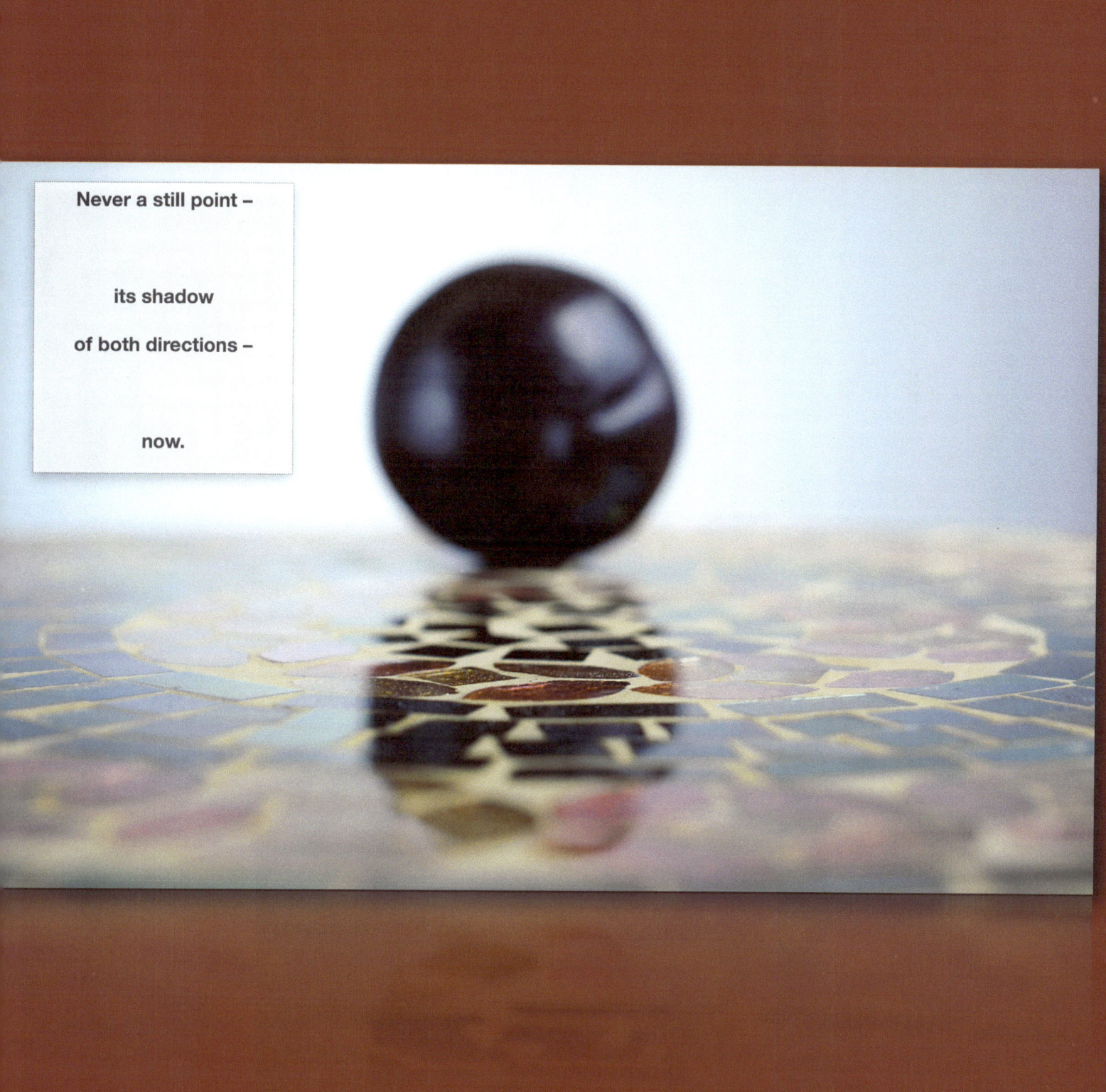

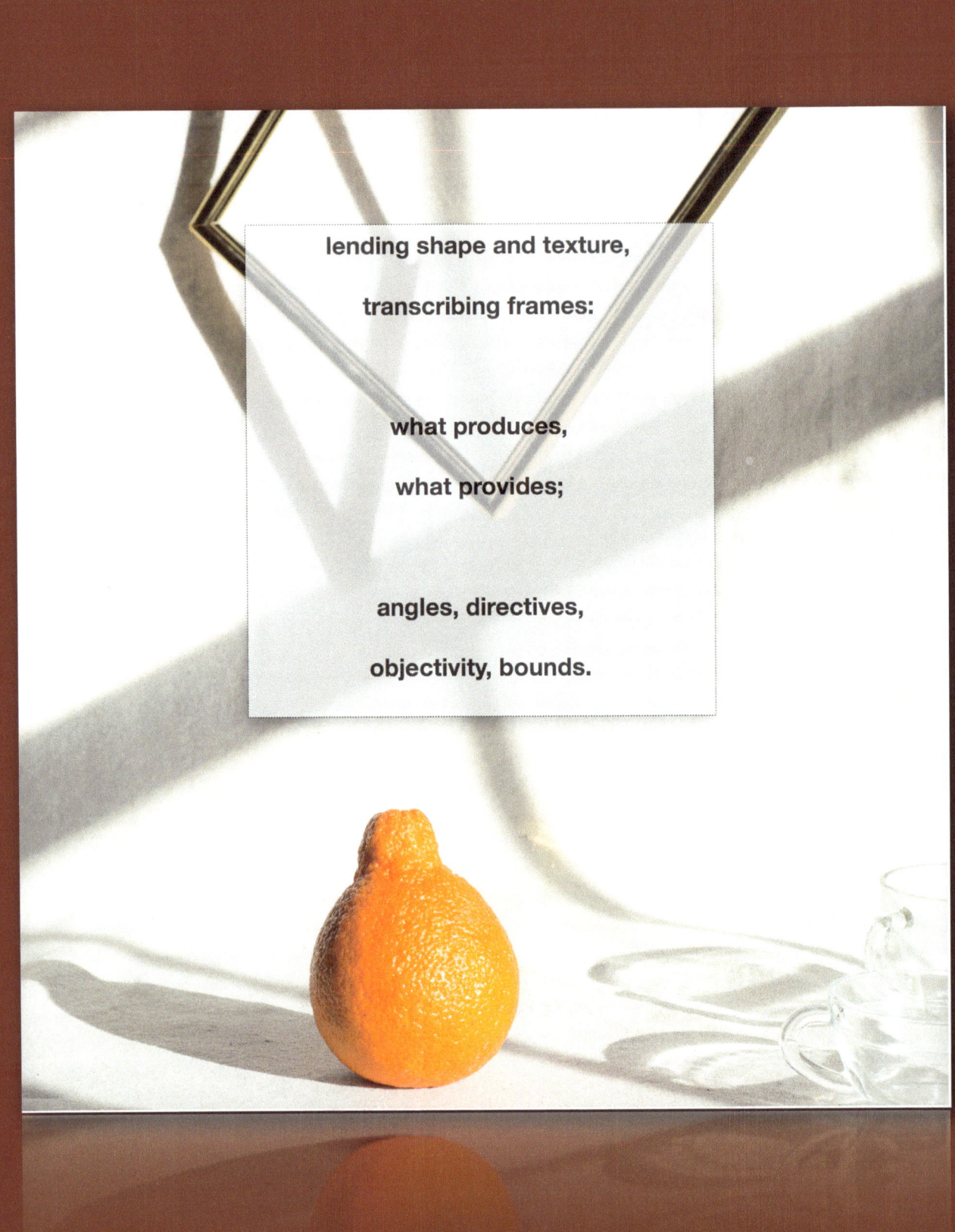

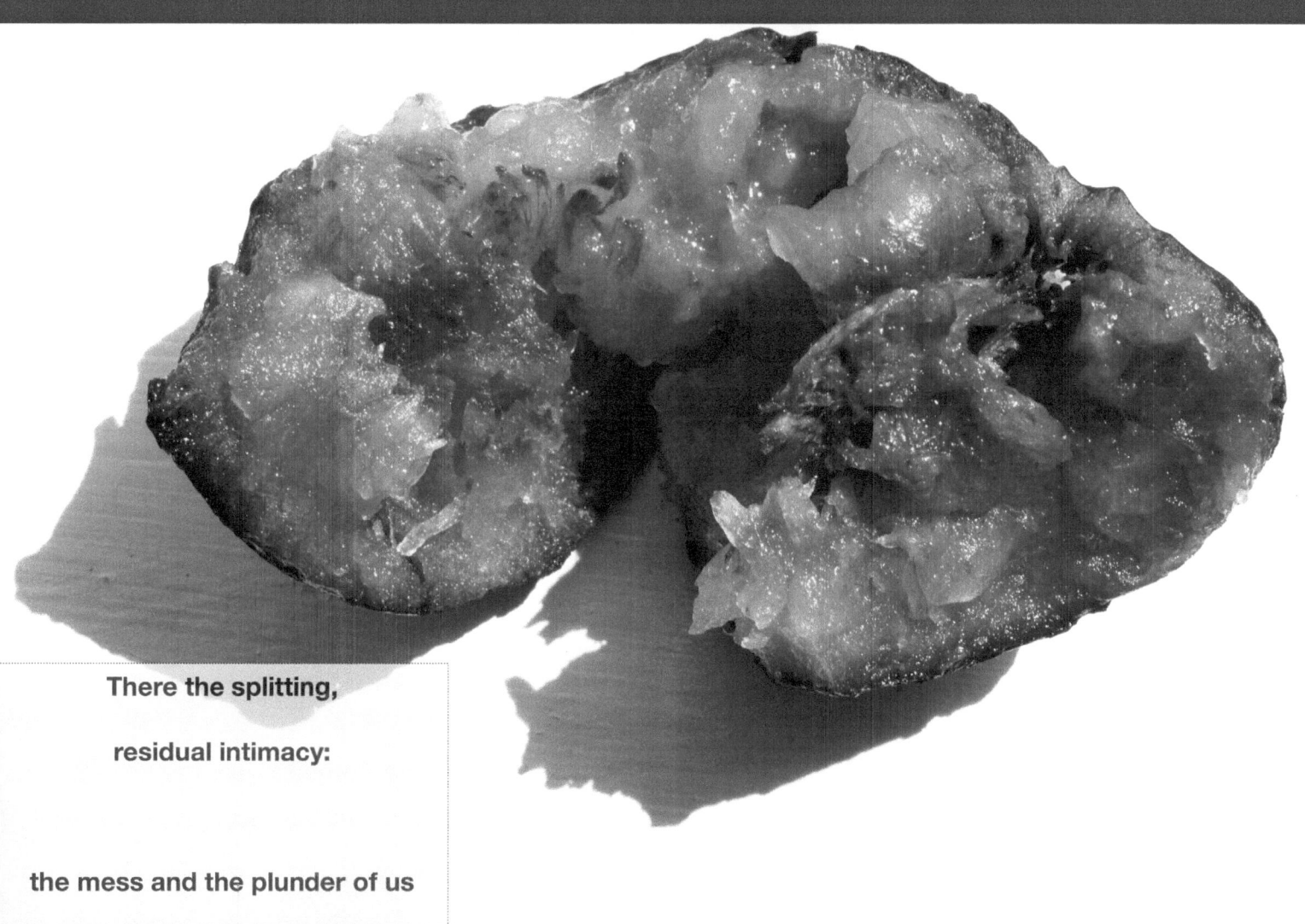

There the splitting,

residual intimacy:

the mess and the plunder of us

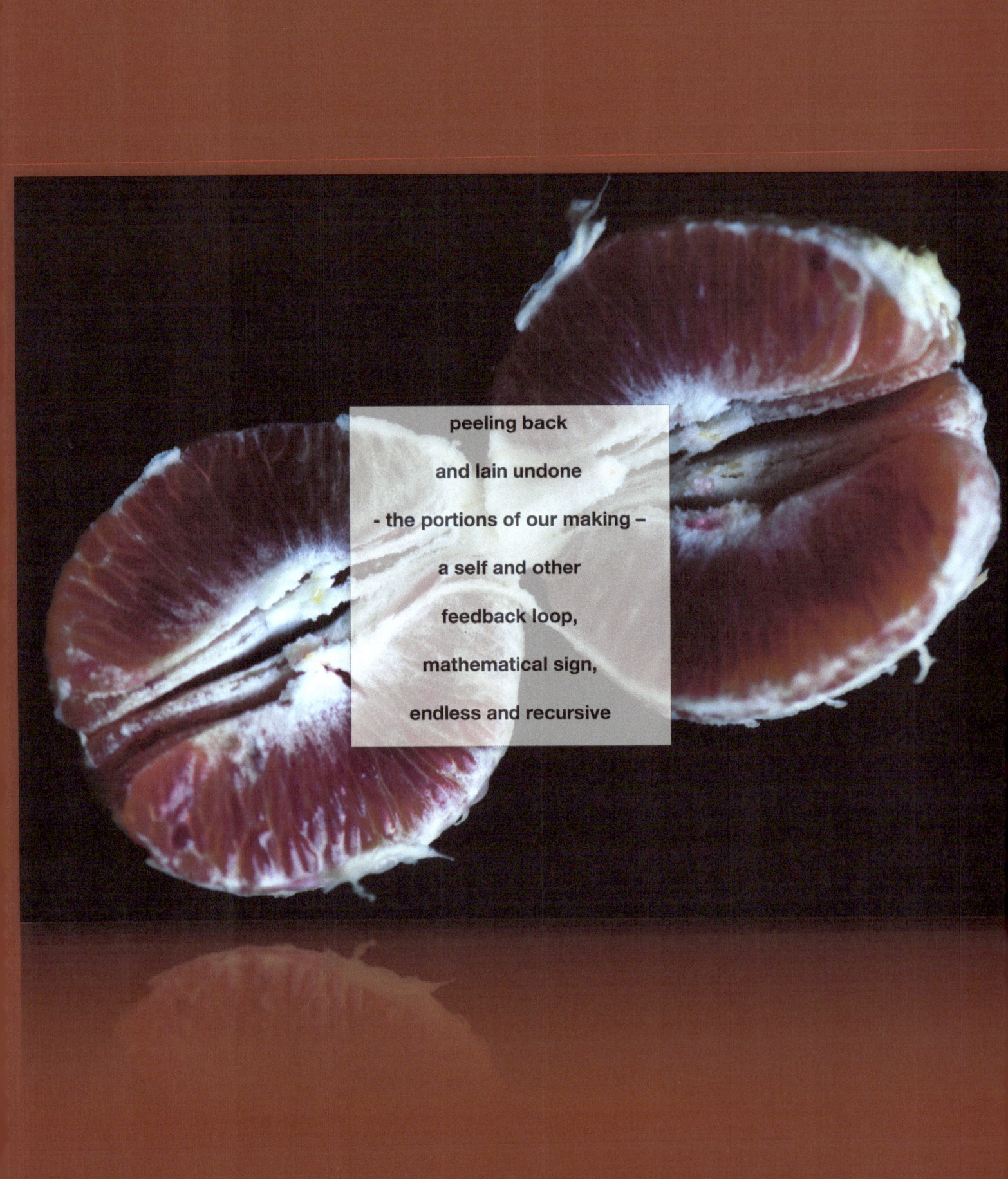

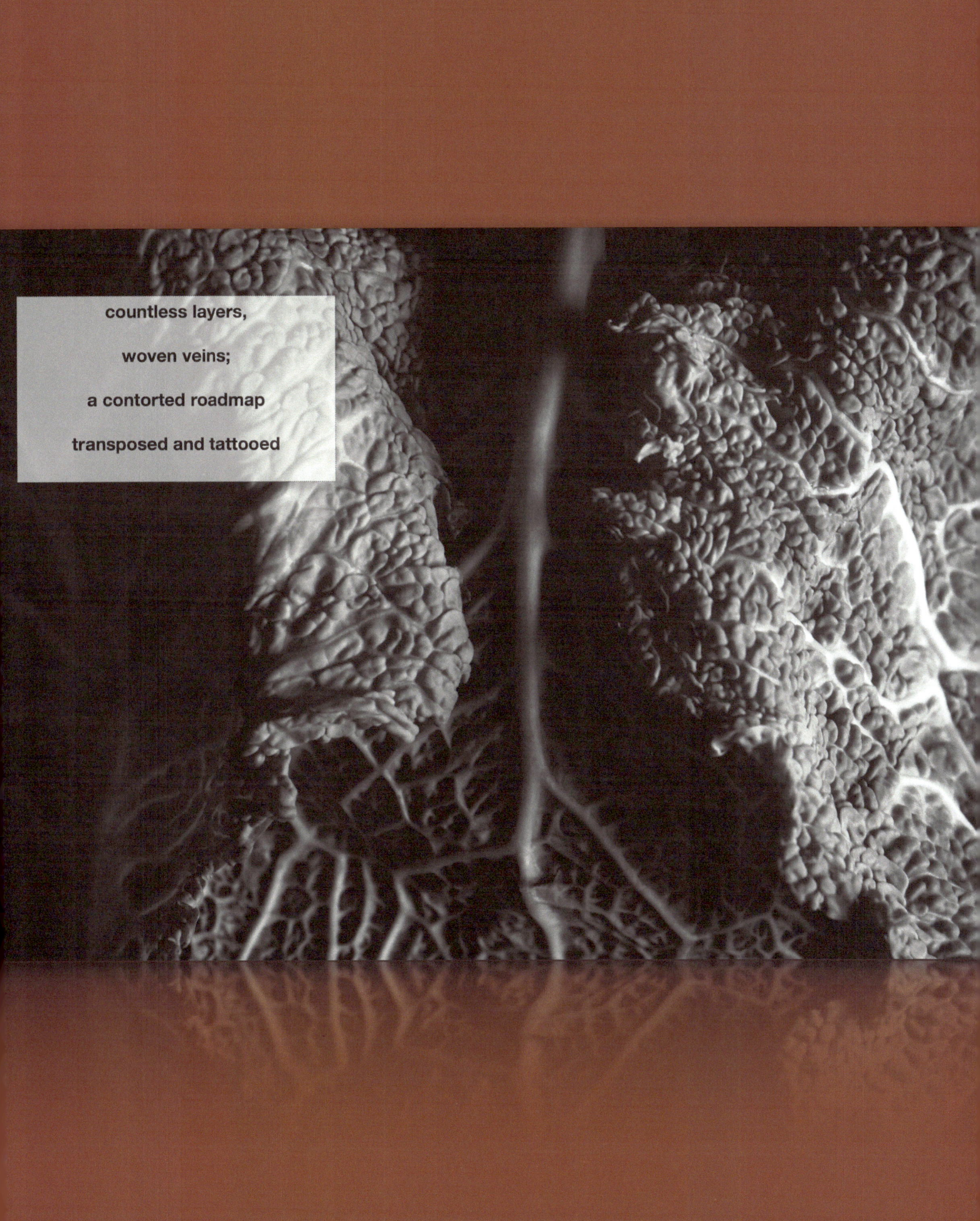

countless layers,

woven veins;

a contorted roadmap

transposed and tattooed

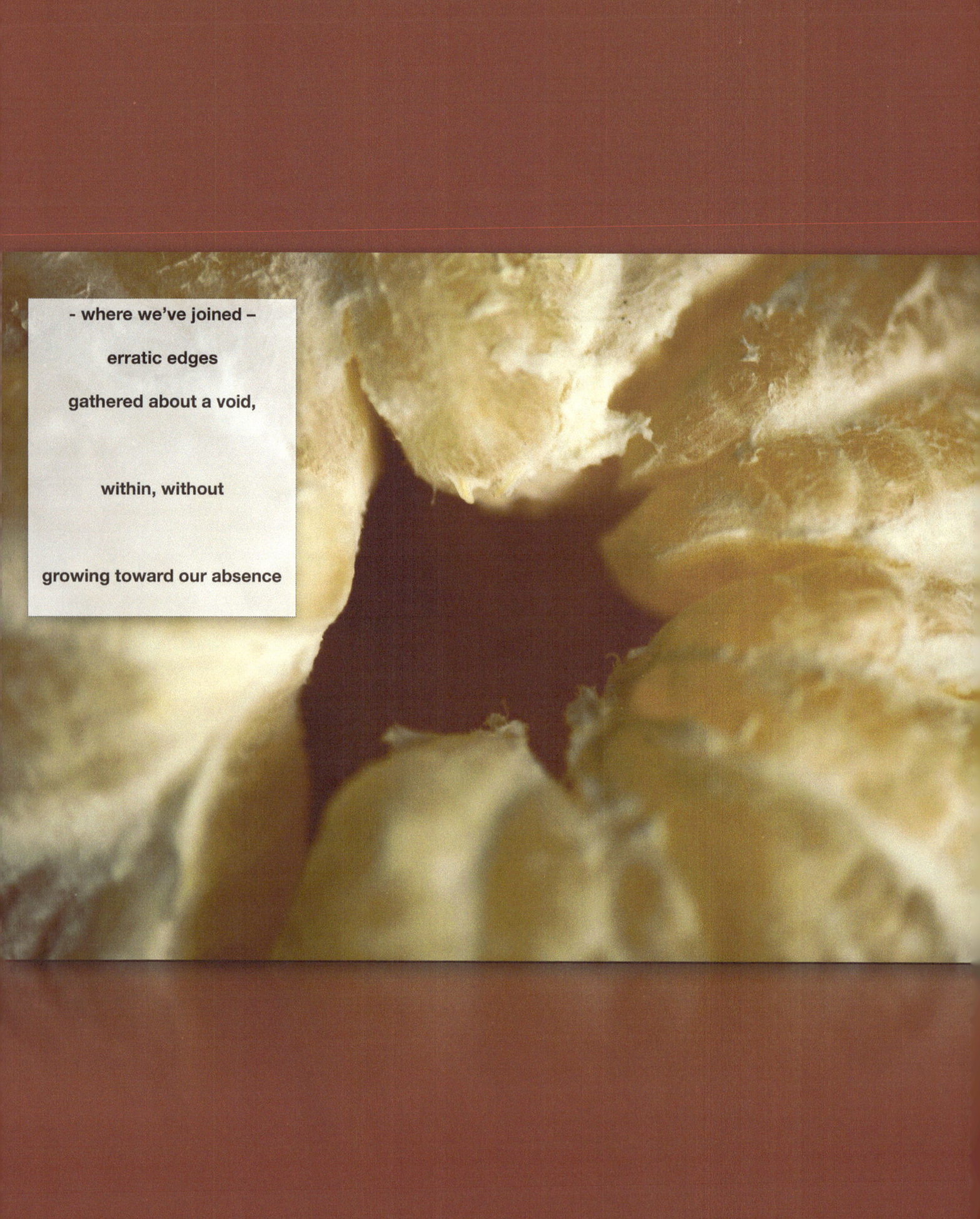

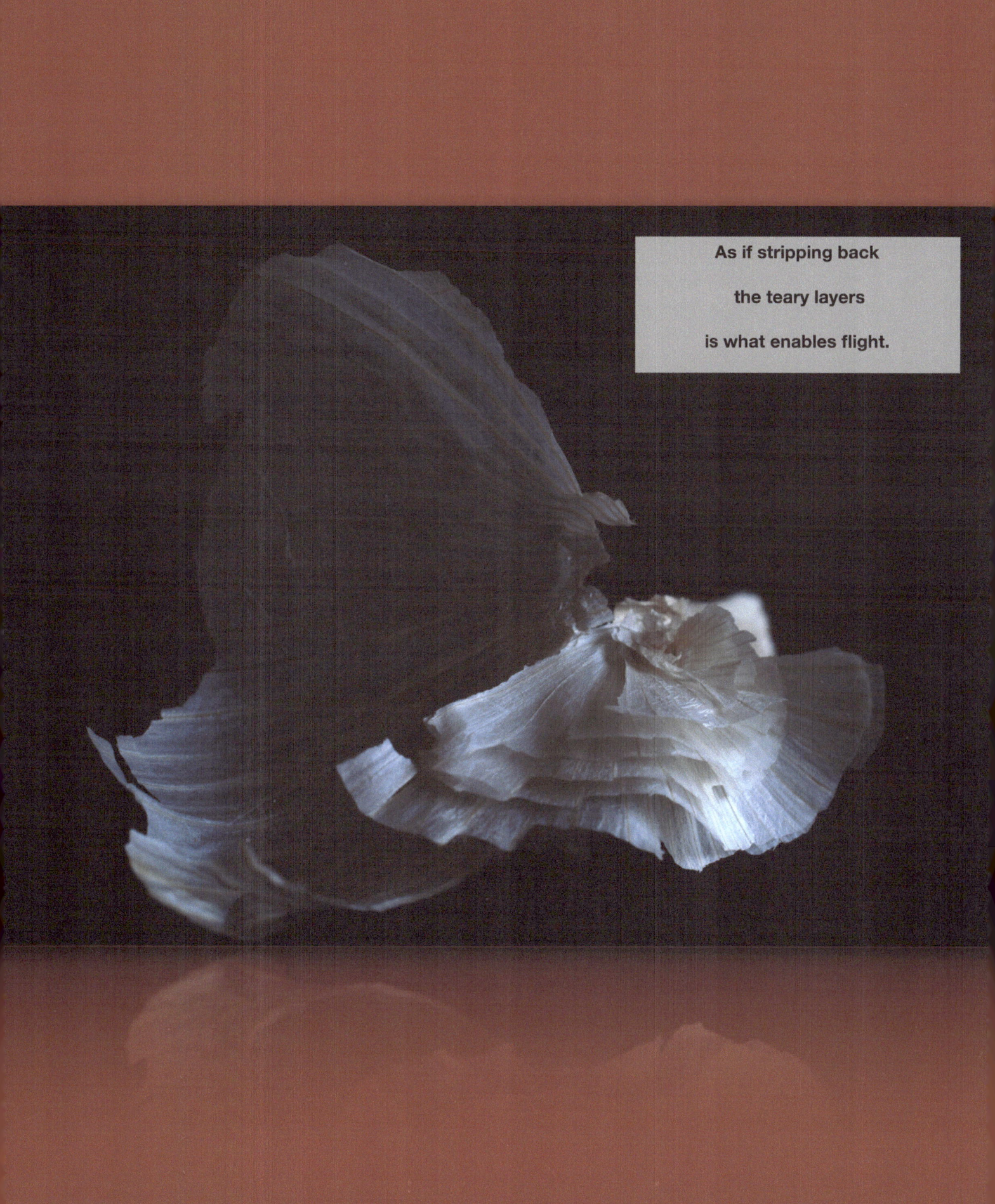

As if stripping back

the teary layers

is what enables flight.

Grace Cavalieri

Going Through the Files

I wish I didn't open that one of the seed catalogue that said *Hoorah for Summer*. I want you to know, Ken, I'm still psychic for what it's worth. I saw Angel holding a brown black cat in her arms and when I told the boys they said *Yes!* There is one that comes around all the time. Angel didn't believe me at first as she thought she'd sent a photo but she hadn't. I don't know why it matters but I like having a special gift, a look inside the world which tells me that time and distance are just circles of thought we are closed in— and then when the Azalea dies out front, which it's almost starting to do, I won't have to say *Oh No, OH NO*. Because even now I can't look at them as beautiful as they are because I know what's coming.

Grace Cavalieri

Glass Metal Salt

Your hands on my neck so transparent
I could see through them in my sleep,
as I move into the city of windows lying at my feet.
I am the only 3rd dimension
on a flat map world—

My Monk in the machine! Talk to me. Anything,
Tell me how it breathes for you, pumping
against your will. Tell me how you love heavy metal,
my pilot, my race car driver, my sculptor,
how you want to get your hands on it, make it move,

fly, shape and burnish it. I see you know—it's winning,
This is the one thing you cannot bend,
but if I know you, and I do — you'll die trying for command.
What am I now? A chess piece on a flat glass floor, breaking beneath
my feet. A note in a bottle uncorked, unread,

unless you'll rip the tubes out, breathe on your own, before
I leave to turn back one last time.
Please call out to me. Say something, Tell me who I am now.
Even Lot's wife must have had a name before
they called her Salt.

Grace Cavalieri

Skin

The skin on his hands was getting thin Thin bones beneath the silent skin I think the skin was getting thin Perhaps from so much sand and wind Or maybe he was getting old That's what I'm told Or maybe wind was circling To take him spinning circling He was so very interesting And I was also interesting Things we thought and said and What we'd bring That's why I keep His book open by my bed Just to skim his life Let his thoughts fly out Let his thoughts take wing Release the sins still on our skin But I still smell his skin So he won't become An idea vanishing Vanishing and taking wing To become a prayer in thin air The air of dreams I love the circling dreams Where he is in or out But never dead In or out alive Instead But never ever dead Make a prayer to him His thin skin vanishing Pray for women watching men Whose skin grows thin Think of this A dangling braid Down my back Who would brush it now Untangle my long hair But my hair is not a braid It is short and thin There are no hands no brush no hands Just the wind circling The thin vanishing wind.

Timothy Brainard

What If That Were Me? Is What I Wouldn't Let Me Think.

i saw him
walking, skinny
bone skinny
pulling
a cart
against
the heat of
an Arizona day.

his shirt was
dirty white;
his skin,
his skin was
black;
his cart was
silver metal and
his walking stick was
wood.

he walked,
i thought, without
direction: only
this steady pulse
of feet on
hot concrete
saves him from
the sun and
Phoenix
cops.

i saw him
walking, skinny
bone skinny
pulling
a cart.

i lowered
my head, put
the camera in my
pocket,
then
walked
back to my car.

Timothy Brainard

An Image Of The Images Making Days These Days

The shop was a hive of lazy bees.
Earlier, the house was a shadowed den;
later, the effect is slightly altered.
At work, the minutes pass like rain beneath
our greased and sooted palms.
On my bike inside a morning yet to dawn
I watch a headlight push my shadow
to a figure stretching tall:
twenty feet or more of this new
effortless companion, silent ghost.
At the shop, tall doors remained closed,
sheet metal eyelids, slow to wake.

Timothy Brainard

There's a Knife Inside Me You Have Never Met Yet Met

why can the martyr not find happiness?
the martyr does not find happiness; the martyr creates happiness.
for others. at his own expense.
yes, at his own expense.
is he, then, slave to those around him?
he is free, and alone. desperately alone. and always afraid.
can he never be satisfied?
he cannot. he is empty, he is free.
but never satisfied.
never.
is he angry?
he is not.
is he sad?
he is a silent cloud of heartache in a sky of careless suns.
he is made of sadness.
he is made of sadness.
but how can he survive it?
he cannot.

While writing for some is an exercise or ambition, Timothy Brainard is not shy to admit that writing for him is a matter of survival: it's therapy. He does not claim to write for any other reason. All of my best work is personal, Tim says. I don't write to be heard; I write because I simply can't not. Settling in more recent years on poetry as a preferred medium of self-expression, Tim maintains a poetic journal-style blog at www.timbrainard.com.

Marcus Slease

Marcus Slease was born in Portadown, N. Ireland in 1974. He has lived all over the world, including 18 years in the United States. He currently lives in London and teaches English as a foreign language. His poetry has been translated and published in Polish as well as in various literary magazines in the U.S., U.K., and Norway. His latest books are Mu (Dream) So (Window) and The House of Zabka. A recent recording of a reading from Mu (so) Dream (Window) is available on You Tube.

You have two new books that just came out. One is a novella excerpt of a Polish fairy tale. How did that come about?

The first book Mu (Dream) So (Window) was taken by a wonderful press in Portland called Poor Claudia. They did an amazing job. Handmade books with beautiful paper and a butcher wrap. I love how the book feels in my hand. I sent the manuscript to them during an open reading period. I was very happy they took it. It was a surprise really. I am not always the best judge of my own work. Most of the poems in Mu (Dream) So (Window) were written while I was living in Seoul, South Korea in 2006 and revised in London in 2012. I let the manuscript sit for five years while I worked on other projects and then I found a new way to re-enter the manuscript after reading Ariana Reines' Coeur De Lion. Reading Coeur De Lion allowed me to re-see my experiences in South Korea with a more directly personal lens (e.g. confessional) and reshape the manuscript into a project with connecting poems rather than individual poems. The more philosophical aspects that reflect on my wanderings and world travel were in the original but I felt it needed something else. This often happens. I read a book that blows me away (in style or/and content) and then I reenter one my gestating manuscripts and complete it with this shift in perspective or new tool in my belt etc.

The publication of an excerpt from the novella was another happy accident. I saw a call for original or re-told fairy tales by a press called Deathless Press. Their advert sounded enticing since the books were going to be handmade (I am a sucker for really well-made books/collector's items). I was working on a novella, The House of Zabka, so I sent them the section that was centered around a fairy tale in a Polish forest. I was reading a lot of Bizarro and absurdist literature at the time. Again, like Mu (Dream) So (Window), I found a way to frame my experiences of living in a foreign country (this time Katowice, Southern Poland) with what I was reading. This time the frame was less confessional and more surreal and absurd. I wanted to throw as much stuff into the novella as possible. Alice in Wonderland, Stephen King, Polish fairy tales, the film Stalker, the poet Kenneth Koch's novel The Red Robbins, the short stories of Richard Brautigan and Aimee Bender, the novels of Shane Jones, Tom Robbins, Kurt Vonnegut, and Cameron Pierce as well as my personal experiences of living in a non-touristy and gritty part of Poland. I am still working on other parts of the novella and hope to finish it by the end of the year.

How many publications do you submit to a year and how many of them accept your work?

I took a six year break from doing a lot of submitting while I traveled the world and wrote in various notebooks. During that six year break I submitted work maybe five or six times. I just started seriously submitting again about two years ago. Both Mu (Dream) So (Window) and The House of Zabka were the result of submitting during this last year. I would say I have submitted to about 60 literary journals and presses in the last year. So far the acceptance rate is about 15%. I like to read widely and my aesthetic can change dramatically so I try to submit widely too. Of course I read the journal and make sure I like the work they publish. I often submit something and then immediately begin revising it. One story that was recently published in Word Riot was rejected by seven literary journals. Each time it was rejected I took another look at the story and made some minor changes but sometimes the work just needs to find the right home. It is sometimes hard to know whether a work needs more revision or just needs to make the rounds until it finds the right fit. Sometimes the selection procedure seems a bit haphazard and whimsical *and so it seems good to sometimes trust your own instinct and not cater too much to the writer's market or period style(s).*

How long have you been publishing your work?

I have been publishing my work since about 1999. But my first "significant" publications came during my time at the MFA program at UNC Greensboro (2001-2003). I won an AWP intro award and one of poems was published in Hayden's Ferry Review. Then my work was picked up by lots of magazines that did not draw a line in the sand between so-called experimental and more mainstream aesthetics. Some of them encouraged a hybrid between experimental and mainstream poetic practice. Places like Octopus, Diagram, Conduit, Forklift, Ohio, miPOesias, Columbia Poetry Review and so on.

Since I moved back to London at the end of 2010 I have been publishing quite a lot again. It is fun to get back in the game. I needed to resettle in a place with English as the main language. I am using my notebooks from Korea, Poland, and Turkey to create various book length projects of both poetry and prose. It has been an exciting time for new creations/projects.

Write a poem on the fly about a fly for us.

> THE FLY
>
> I grew up with heaven and hell
> and there was a lot of hell
> but I kept a heaven inside me
> lately a lot of flies
> having been showing up
> in my dreams
> yesterday it was a fly
> made of cardboard
> in the front yard
> of a former home
> in Hurricane Utah
> it had tiny beads for eyes
> and sat there
> in the front yard
> waiting for me to speak to it
> and then the dog came
> and dug a hole
> a big giant hole
> and this black and white
> shepherd dog moaned
> in that hole
> and the moaning became
> my own voice
> as the dog disappeared
> and it was me in that hole
> and that cardboard fly
> with its beady eyes on me
> waiting for me to speak
> but there was nothing
> more I could say

What else do you enjoy doing besides writing?

Well I am getting addicted to good food. My girlfriend and I have been doing quite a lot of cooking, especially on the weekends. It is one of our favorite activities. We are becoming real food lovers. Recently we have been cooking Indian. Curry (vindaloo), Bombay potatoes, aloo sag, aloo bhaji, chicken dupiaza etc. etc. But we still haven't figured out how to make great homemade nan bread. I think we need a better oven.

What would the list of your social network of friends be if it included dead poets?

Ted Berrigan, Frank O' Hara, Walt Whitman, Sappho, Basho, Siddhattha Gotama, Kathy Acker, William Burroughs, Jack Kerouac, Allen Ginsberg, Kenneth Koch, Emily Dickinson, Anna Akhmatova, Pablo Neruda, Nicanor Parra, Marina Tsvetaeva, Elizabeth Bishop, William Butler Yeats, Marianne Moore, Anais Nin, James Schuyler.

How do you find living abroad different from the poetry scene in the States?

Overall it seems a lot more formal and compartmentalized in the U.K. than the United States. A lot of the poets have long cvs and seem to almost all come from university programs in English or creative writing and want to teach in university. I think that was/is a big part of the scenes in the U.S. as well but there is more variety and cross breeding. The experimental/avant garde and the traditional lyric or narrative poetry are on opposite sides in the U.K. and don't do much cross breeding. There are exceptions. Amazing exceptions like Jeff Hilson, Tim Atkins and others. And there is an amazing renaissance of collaboration between artists and poets via the various projects of SJ Fowler. So it is also an exciting time. I do miss the more informal readings scenes in the U.S. though. The poetry is a lot more diverse and interesting in the U.S. than anywhere else I have lived (of course the U.S. is a much bigger country than the U.K. so that accounts for a lot).

Laurie Kolp

Ear

A listening ear, spongy ear.
Voice of infinity, a spiral,
life's journey to the center,
a conch shell whisper
methodic waves, an ear
with strength and fortitude.
Wing-like mystery, a breath
in the wind, tympanic labyrinth.

Not a mallet to drive a point across,
or baby artichoke with Orecchiette
to soak up saucy meat like gossip.

An ear auspicious in intentions,
your ear compliments my tongue.
A lobe pierced, diamond stud
I clink my teeth on.

Tree trunk, conchoidal bole
with rings, your ear our growing love.
The ear that doesn't want to hear
those three words. I say them anyway,

but you chop them up like Van Gogh.

Laurie Kolp's full-length poetry collection, Upon the Blue Couch, is slated for release in March 2014 by Winter Goose Publishing.

Amy Serrano

Award-Winning filmmaker Amy Serrano shot, produced, wrote and directed the feature-length and critically acclaimed documentary, "The Sugar Babies: The Plight of the Children of Agricultural Workers in the Sugar Industry of the Dominican Republic". While based in Miami, Amy also wrote, produced and directed the U.S. co-production for the feature length film "MOVE!" Her body of work includes directing and producing the PBS broadcast "A Woman's Place: Voices of Contemporary Hispanic-American Women" and the award-winning "?Adios Patria? The Cuban Exodus" narrated by Andy Garcia (Berlin Film Festival, Best Documentary New York Independent Film and Video Festival, PBS). She executive produced the PBS broadcast and Emmy-Award nominated "Cafe con Leche: Voices of Exiles' Children" and associate produced the Emmy-Award nominated "Havana: Portrait of Yesteryear" narrated by Gloria Estefan for PBS.

Tell us about your new poetry book.

While our preconceived ideas about topography mentally take us to physical spaces of land, through poetry, I feel we may venture and navigate places surrounding the intricate and delicate cartography of the human body, mind, and spirit. My new poetry book is therefore titled "Of Fiery Places and Sacred Spaces." It refers to a selection of poems about life—and love longed for, lost, and then re-encountered--representing the poetics of the astonishing places without, and the wondrous places within.

This collection of rhythmic words and ideas thereby represents a sort of geographical chart, sometimes based on physical locations which are oftentimes sacred and always inspiring; or body, spirit and mindscapes that are always warm, eternally hopeful, and sometimes fiery. Therefore, through the medium of words, I chart and explore physical, emotional and spiritual movement, the outer and inner journeys of the body, mind, and spirit.

What other projects are you working on?

I am very inspired by the life of the last living Tuskegee Airman in Louisiana, so I am documenting this via the film, "AIRMAN: The Extraordinary Life of Calvin G. Moret." I am also very excited about a multidisciplinary and transformative cultural initiative that celebrates, elevates and uplifts Cities+Citizens. "This Is Who We Are: Self Portrait of a Great American City" will explore the meaningful impact of place upon identity via Biennial City Self Portraits presented within each city by its cultural leaders! We are launching the model in my hometown Miami but looking forward to recreating this socio-cultural experience in other Great American Cities! On this project I serve as Founder, Concept Creator and am also Curating the Cinematic Arts Team in Miami. My long term project is a fictional account I've been writing surrounding the adventures of a globetrotting, world saving documenting filmmaker named Cat de Lara.

What was the first poem you had published? Please tell us how you feel about that poem today.

The first poem I had published is called "*Island*." As I was born in Cuba, an island first inhabited by native populations later decimated and ultimately annihilated by Spanish colonial powers, the poem refers to all those that would view a body of land as something to be overpowered, taken, conquered, claimed.

However, the poem also refers to the colonization that sometimes occurs within relationships. Therefore, it's also about preserving the integrity of a human being whose body, mind or spirit are not to be conquered, but rather shared with a like-minded *other*. When I recall the type of power driven, selfish, conquest-minded creatures that inspired it, the poem still carries meaning. But I prefer relating it to the feeling I have for people and places as sacred entities to be respected, cherished, and celebrated. In fact "*Island*" ends with a note of hope.

Amy Serrano

How much does your cultural background come into play with your projects?

Well the struggle for human rights, dignity and possibility for all humanity is something for which I seem to be hardwired to envision and convey.

I once had my astrological chart done and it was explained to me that Cuba is the island where I was born, but not the place where I was ever meant to live. The seer also told me that Cuba's purpose and experience in my life was to serve as the "original wound" for me; so that I would better understand the pain of separation and truly empathize with others that suffer because of conditions related to abuse of power. I so clearly related to this and suppose that to this day, it explains why a lot of my work involves bringing and keeping people together, elevating their conditions and possibilities and notwithstanding, the constant search for Home—but a search for a Home that is not built on sand.

What is the best place to have a Cuban sandwich in Miami these days?

I am mainly vegan, and part time vegetarian, so I'm probably not the best person to ask about a traditional Cuban sandwich, but when I visit Miami, I just ask for a Cuban sandwich without pork and ham—just pressed Cuban bread, Swiss Cheese, extra pickles, mustard, mayo. This request leads to all sorts of quizzical looks from wait staff but that is my version of a Cuban sandwich. So if you still wish to know, I'd have to say the best place for [vegetarian] Cuban is at Sergio's on Coral Way, or at the Latin American Restaurant at the corner of Coral Way and 107th Avenue [by FIU].

Now that I live in New Orleans though, I can easily tell you the best place to have a mean [vegetarian] *Muffaletta*!

How much art comes into play with your poetry?

As will become evident upon viewing my self-sketched, self-portrait, I cannot draw to save anyone's life, much less my own. Therefore, I have great, quasi-reverential appreciation for the visual arts. Great art—be it visual, musical, literary, performance or other—serves as a fount of deep inspiration for threads that collect and are later woven into ideas that enable poems that we see in our minds, and are later transformed and committed to the written word.

Is there a poem that you favor in your new book? Why?

My favorite poem is "*Of Shelter and Rain*." It speaks of the dream of someone whose arrival you've idealized and longed for and who at long last shows up. *The Valiant Vessel.*

OF SHELTER AND RAIN

Outside,
it rains very Hard
and Earthbound Water Falls
upon a defiant Winter Garden.

Inside,
it rains even Harder
but I sail adrift on the idea
of what Hard Rain falling
awakens in Me.

Descending drumbeat elixir,
that through Water,
striking and luminescent,
unlocks the Portal possibility
to a Soul's desired Reflection.

So under this long awaited flood,
YOU, finally appear....
and through bittersweet
shades of Twilight,
I venture beyond
grand fortress windows
and let YOU in.

Over heavenly wet Earth,
We finally move,
and like raw Silk,
I breathlessly yield,
to the thirst quenching Splendor,
of this One,
final Surrender.

The grand torrent Rain suddenly stops,
but with waterproof Skin,
drenched and filled
in the warm deepening
Afterglow of YOU,
it dawns on Me,
that if only under the Spell
of this Rain induced Reverie,
Together,
We might be
Shelter.

Bill Yarrow

In My Hometown

in my hometown pinhead Joe
plays mumbly-peg
alone with a sharpened spoon

in my hometown manila
is the flavor and cul de sac
is the address

in my hometown the Catholic girls
know all the words
to "Louie, Louie"

in my hometown the post office
serves Doritos
and lime beer

in my hometown yellow
Ford Falcons
people Old York Road

in my hometown all the crosses
on the mountain
are upside down

in my hometown the Thalidomide baby
just turned
sweet sixteen

Bill Yarrow is the author of Pointed Sentences, a full-length collection of poems published by BlazeVOX in 2012 and two chapbooks; Wrench published by Erbacce Press in 2009 and Fourteen, published by Naked Mannekin Press in 2011. His work has appeared in *Thrush, Treehouse, Contrary*, and *RHINO*. Two chapbooks (Twenty from MadHat Press and Incompetent Translations and Inept Haiku from Červená Barva Press) are forthcoming in 2013.

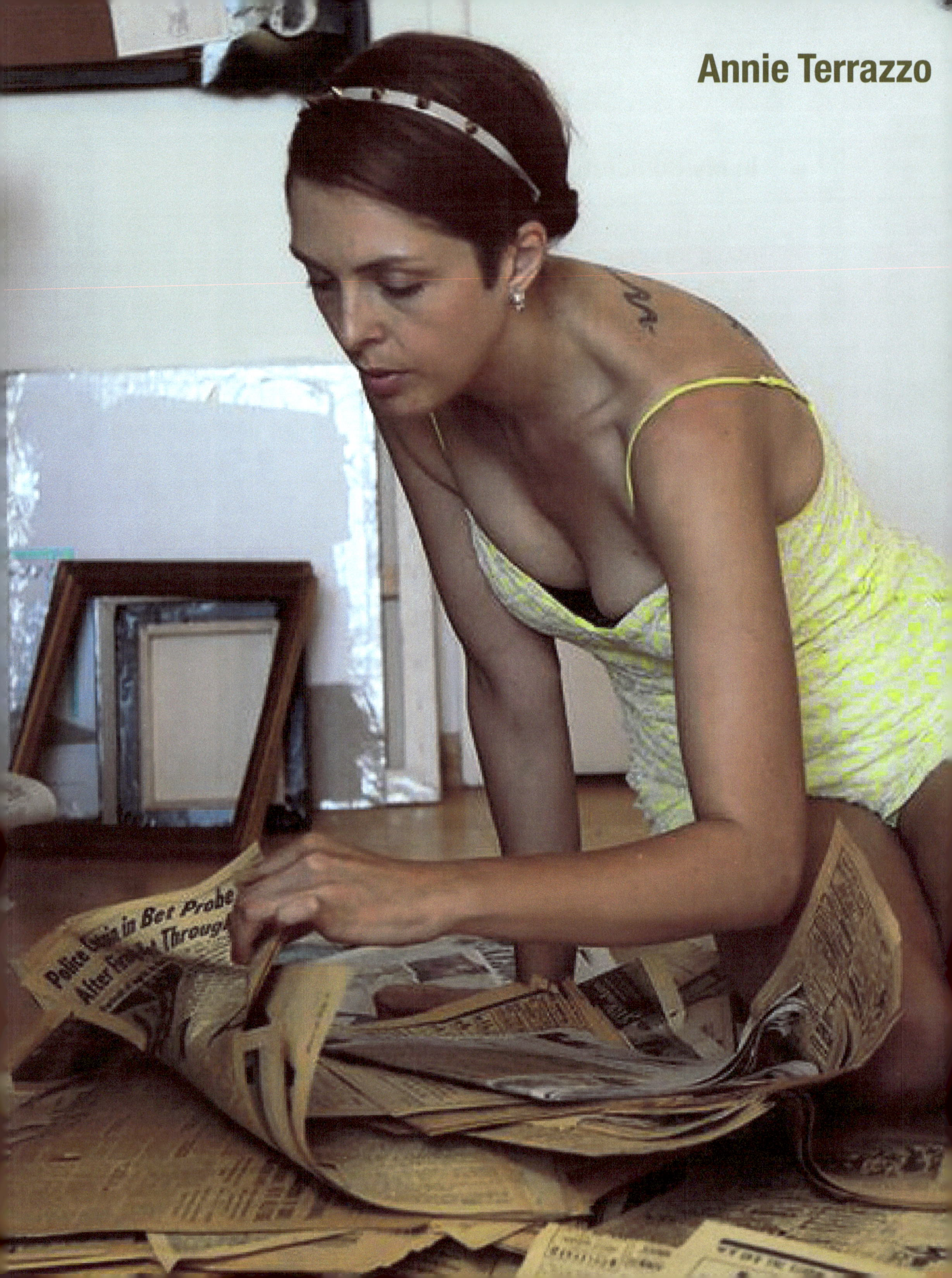
Annie Terrazzo

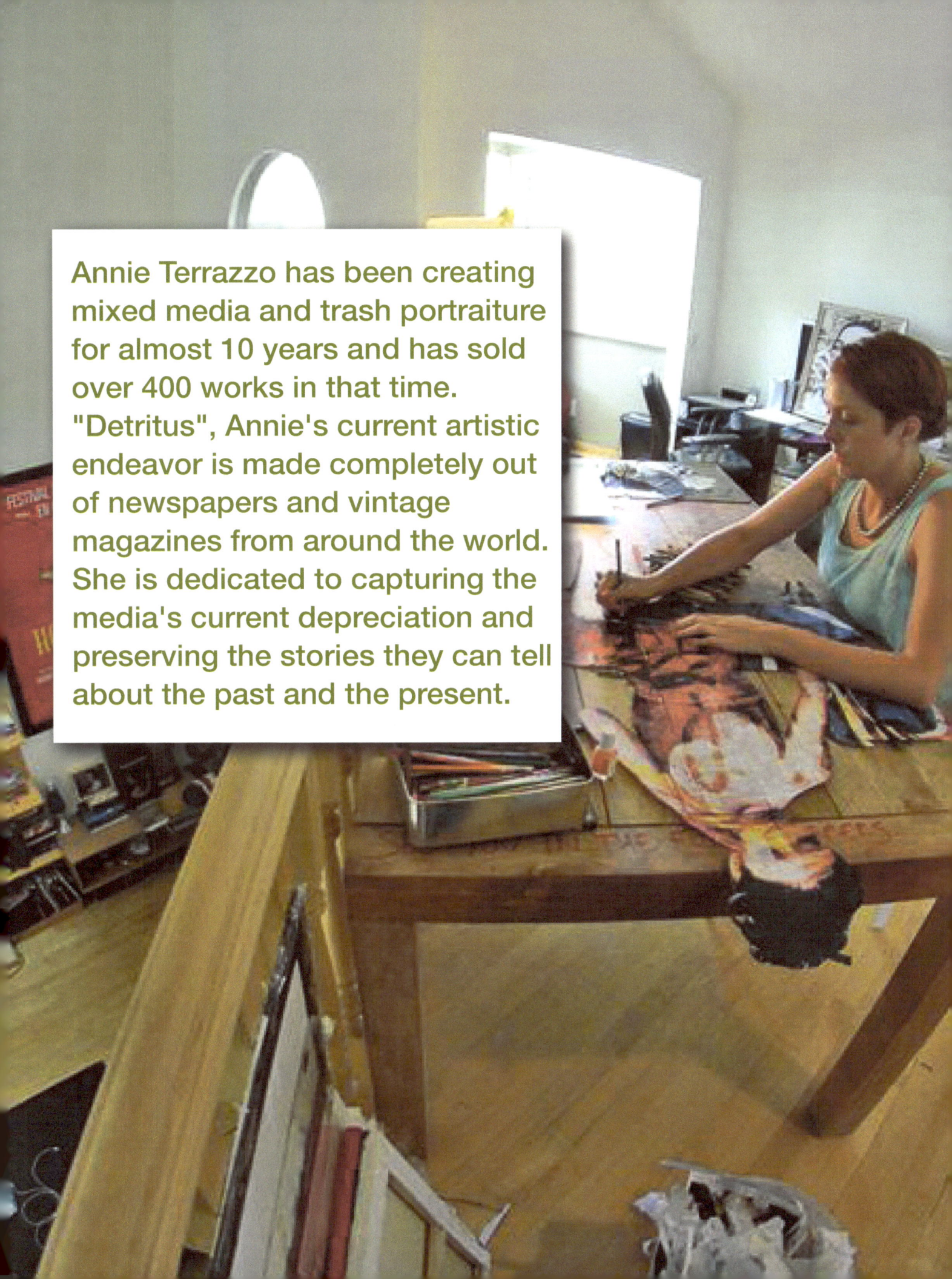

Annie Terrazzo has been creating mixed media and trash portraiture for almost 10 years and has sold over 400 works in that time. "Detritus", Annie's current artistic endeavor is made completely out of newspapers and vintage magazines from around the world. She is dedicated to capturing the media's current depreciation and preserving the stories they can tell about the past and the present.

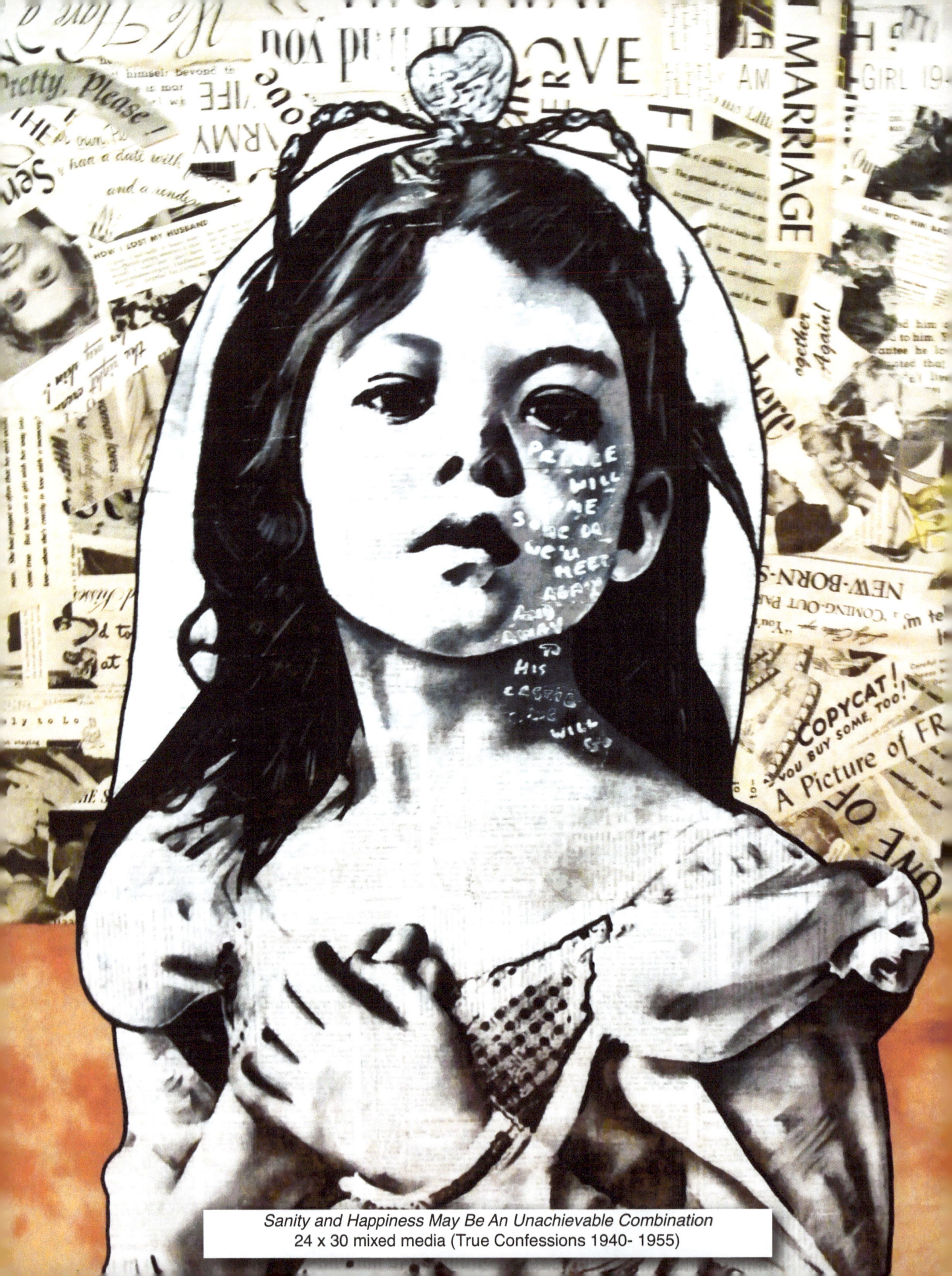

Sanity and Happiness May Be An Unachievable Combination
24 x 30 mixed media (True Confessions 1940-1955)

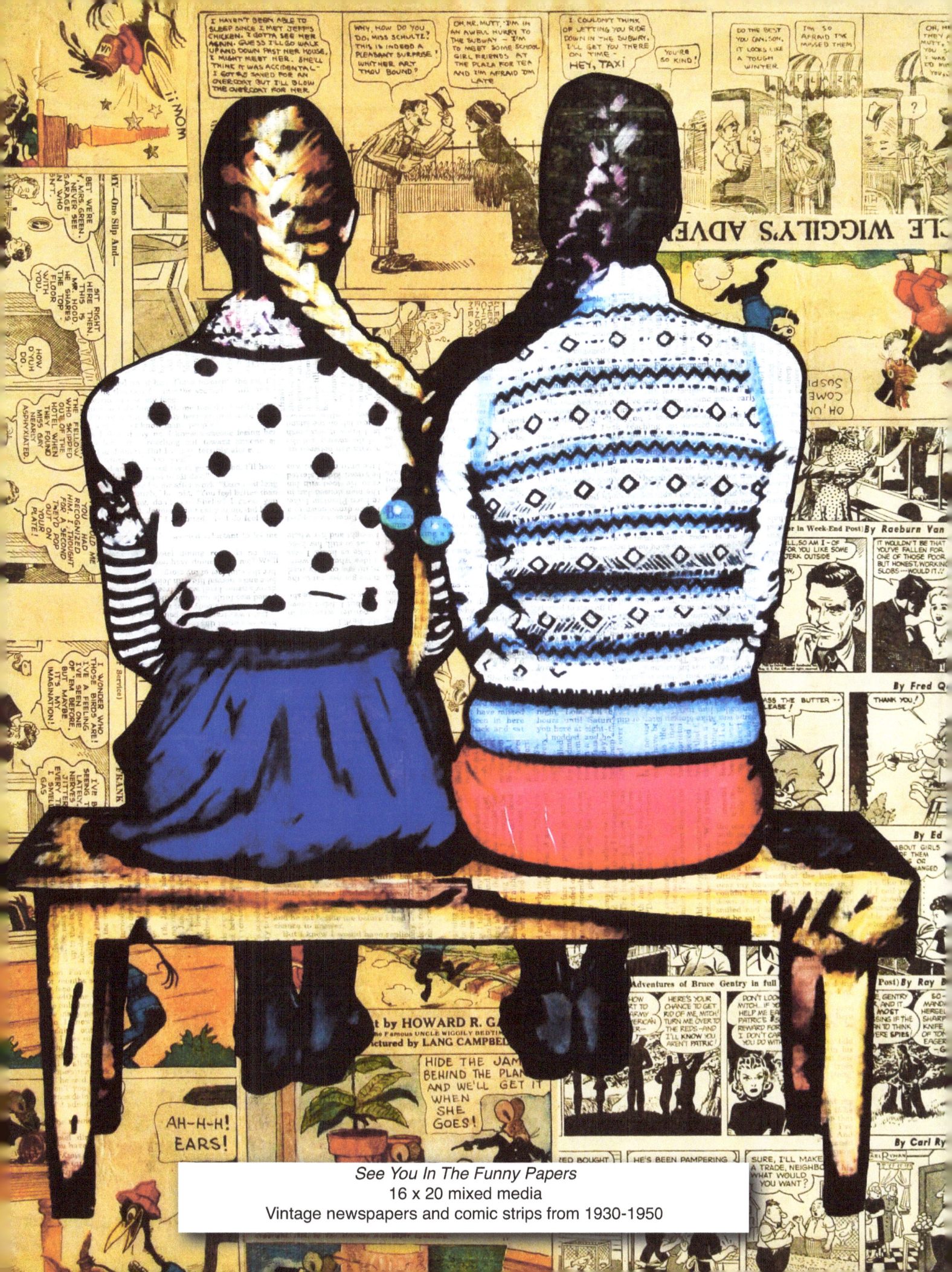

See You In The Funny Papers
16 x 20 mixed media
Vintage newspapers and comic strips from 1930-1950

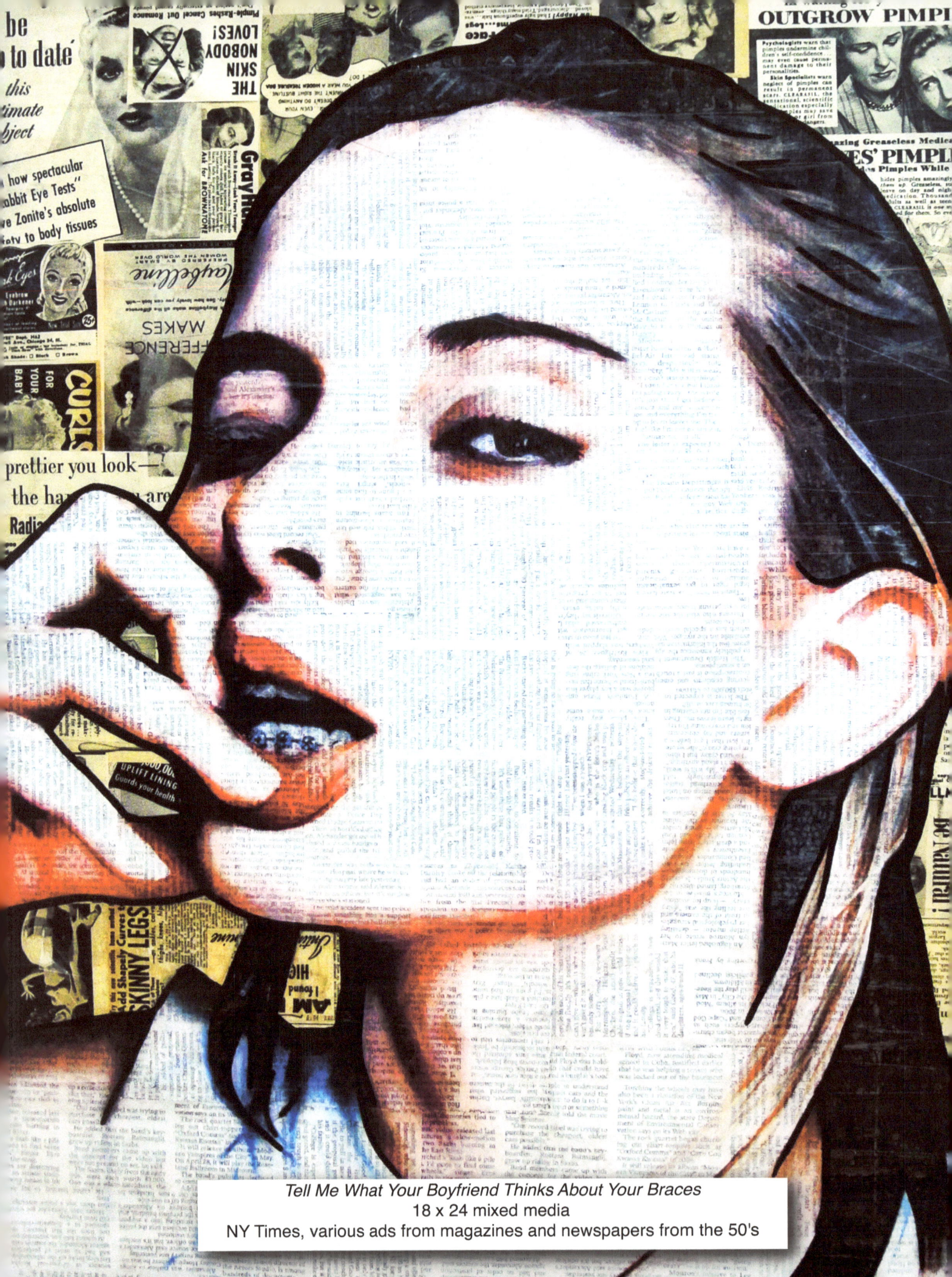

Tell Me What Your Boyfriend Thinks About Your Braces
18 x 24 mixed media
NY Times, various ads from magazines and newspapers from the 50's

Robert Roberts: IDENTITY: THEME AND VARIATIONS
Review by Grady Harp

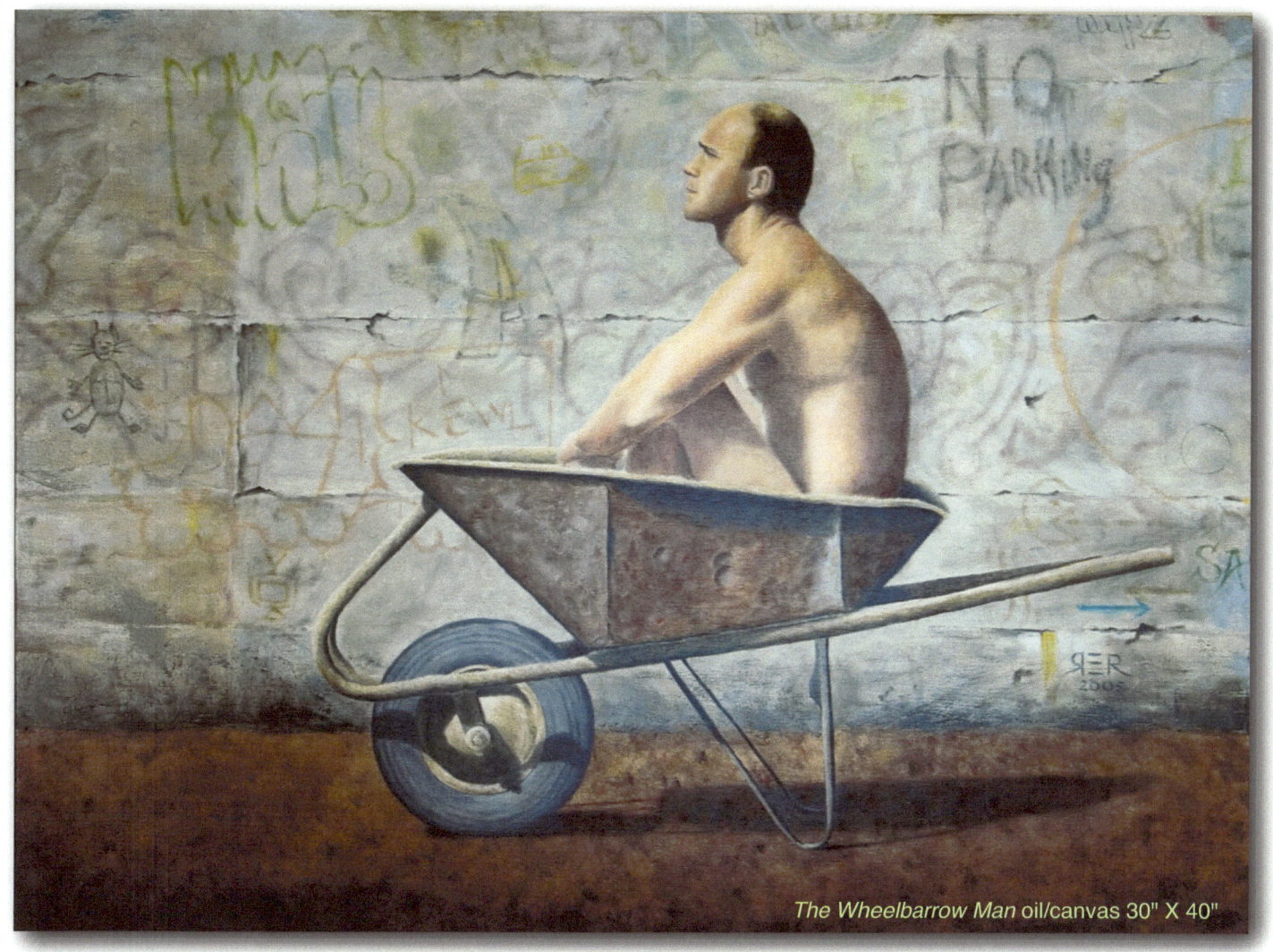

The Wheelbarrow Man oil/canvas 30" X 40"

"The aim of art is to represent not the outward appearance of things, but their inward significance."
— Aristotle

The gentle, slightly surreal, quietly lonely figures Robert Roberts creates in some ways reflect the life of this fascinating artist. His life's journey has provided exposure to various aspects of the arts as a description of his experiences proves. That he has been able to arrive at this time in his life with an informed philosophy of man's relationship to this world as essentially a path of solitude, that each of us must face existence alone, allows him to offer these subtle parables that encourage us to reflect on our own relationship to the world as we find it, as well as to the world of art.

Robert Roberts: IDENTITY: THEME AND VARIATIONS

Born in Prescott, Arizona in 1947 Roberts from his early years was attracted to the myriad aspects of art. Though he never has taken an art course he was attracted to creating images in oil painting, calligraphy, egg tempera, woodcuts and tapestry. His fascination with the Old Masters, both in the subject matter of the depiction of saints, of martyrs, of peasants and in the careful manner in which those Masters created their pigments and media, influenced both his choice of content and an appreciation of the tools of art. Impressed with his grandfather's respect for craftsmanship he made most of his own paints using a glass slab and muller (a stone or piece of wood, metal, or glass used as a pestle for pounding or grinding), often using historic pigments not readily available from commercial paint manufacturers. He continues to be equally attentive to the quality of the painting support, both on canvas or panel. Though Roberts did not attend classes on making art, his curiosity and commitment to craftsmanship lead him to research the history of his field. 'After wading through the writings of respected 19th and 20th century "authorities", after trying some of the formulas and special techniques, one finally experiences "secrets fatigue", and decides - rightly - that those old guys didn't actually have any special secrets. Instead, the secret was an intimate understanding of their basic materials based on generations of experience. The materials were simple: pigment, linseed or walnut oil binder, marble dust or chalk, hide glue. The use of resins was actually quite limited.'

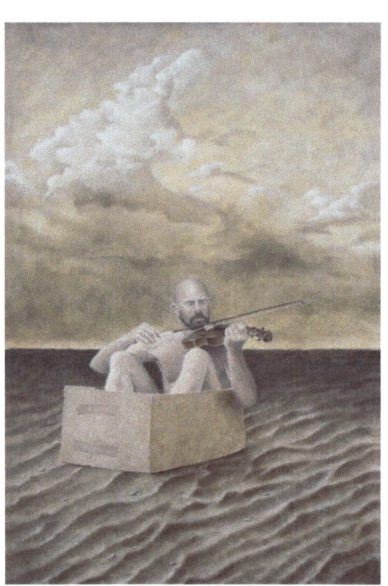

Roberts' evaluation of creating art in modern times has resulted in some rather strong opinions: 'Of all the traditional art forms, modern oil painters interact the least with their materials. Everything is prepared for us - supports, grounds, paints, mediums and varnishes. On the face of it, this is an advantage. But in reality, painters are deprived. Because it's so easy to purchase ready-made supplies off the shelf, we are cheated of the abiding satisfaction that comes from a more hands-on experience of the materials of our craft. Paint manufacturers work very hard to deliver a product with a uniformly consistent texture and with an homogenous body color from one tube of paint to another. For example, we are offered generic, blended earth colors instead of a selection from the richly varied naturally occurring colors. To further complicate things, there is a wide array of student-grade paints. Sadly, such paints are to high-quality oil paint what so-called "juice drinks" are to actual juice!'

Yet with all of this mental and physical and journeyman exposure to making art, Roberts turned his attention to music. After attending Northern Arizona University he was drafted in 1969 into the Army and served as an Army medic until 1972, when upon discharge he returned to the university where in 1974 he earned his Masters degree in Piano and Composition. His next step was enrolling in the American Conservatory at Fontainebleau, France where from 1975 through 1976 he studied with that most famous legendary teacher, Nadia Boulanger, whose pupils have included Aaron Copeland, Philip Glass, Gian Carlo Menotti, Virgil Thompson, as well Burt Bacharach and Quincy Jones. Despite this fine grounding in music, Roberts decided against pursuing the expected Doctorate degree and instead moved to San Francisco where in addition to a variety of jobs he returned to painting.

Pictured above: *River of Sand* Oil/Birch Panel 60"X 40"

Robert Roberts: IDENTITY: THEME AND VARIATIONS

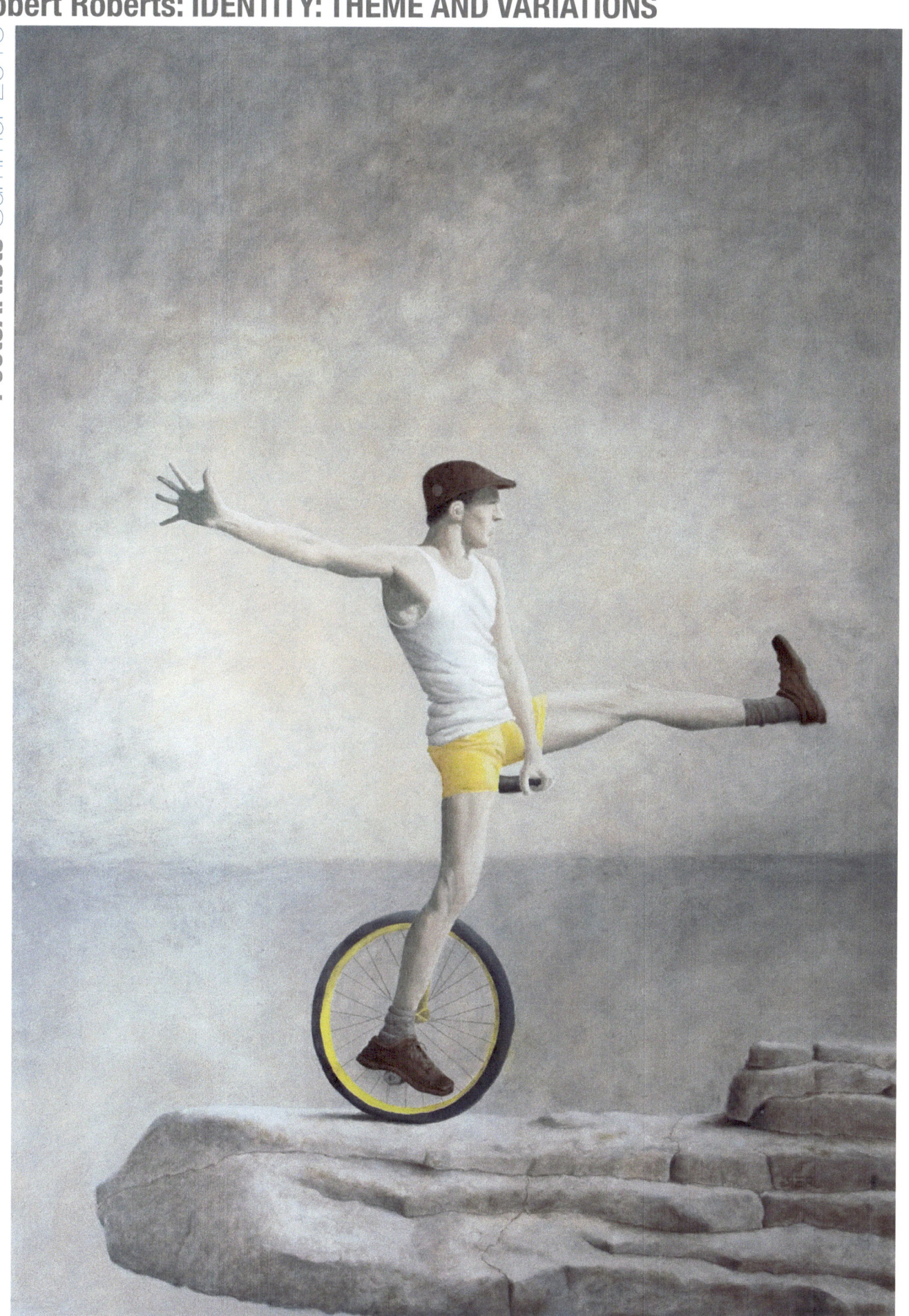

On the Edge Oil/Birch Panel 40" X 30"

Robert Roberts: IDENTITY: THEME AND VARIATIONS

Roberts' choice of subject matter and his approach to the figure is interesting in that, though raised as a Mormon, he is not a Christian, but is instead intrigued by the Christian saints and martyrs that are depicted in the Old Masters paintings. He envisions these hallowed creatures as mystics, quite the same as the mystics from other religions. 'The human form, and human introspection, are things that consistently intrigue me. The human form is endless in its variety and range of expression. The inward, introspective view is compelling because it is a reflection of the soul. Most of my figures are solitary. Ultimately, we are alone, and it is only in solitude that we can discover our personal niche in the universe. Initially, I painted objects. Now I try to paint ideas. Three things that influence me are Spirituality, Symbolism, and the simple astonishment that anything exists at all.'

The constant in Roberts' paintings is his interest in the inward, the reflective – those moments when we are alone within our own world. In his paintings *Mathematician* and *The Sand Writer* his isolated figures appear to be making maps of the journey. In *The Scientist* there is the obvious questioning of nature and man's relationship to it. In *The Wheelbarrow Man* the figure, alone in one of man's own creations, looks past a graffiti wall to somewhere beyond, attempting to find a rational explanation for it all. And in keeping with his concept that life itself is surreal, he juxtaposes real elements with unreal situations, that moment of the impossible, as in *River of Sand* where the violinist performs seated in his cardboard ship on a sea of rippled sand, or in *On the Edge* where the preposterously improbable position of the unicyclist finds him unaware of his impending doom.

Robert Roberts is an artist sensitive to the times and to the state of art as practiced today. 'We live in a general social climate that wants things now, that seemingly can't grasp the concept of patience as the key to great understanding, that has not experienced the profound peace of something as simple as kneading bread. Art and craft inform each other. If painting is a means of personal evolution, then the craft is the fundamental basis of any personal growth. But if painting is only a means to an economic end, then the concept of craft is useless, and expediency reigns.'

Since 1986 Roberts has embraced another art form, that of a tattoo artist and has gained considerable fame in this field. He now lives in Palm Springs, California happily supporting himself with his inking art while continuing to create the oil paintings discussed here. And perhaps he has found his identity in this confounding world, not unlike the figures in his works. His deep respect for technique and craftsmanship is the same, whether his medium is hand made oil paint or ink and whether his substrate is canvas or panel of the human integument. His honesty in his art is reflected in the honesty of his life. The theme and variations of his multitalented artistic expression offer visual clues to that discovered niche, his identity.

"No great artist ever sees things as they really are. If he did, he would cease to be an artist."

Oscar Wilde

Robert Roberts in his studio

Oceans Rising

So many religions bear a flood myth,
detailing our own pitiful demise,
saving a precious few to repopulate the planet.
No one knows what event sparked
the common story. Everyone has a theory,
refusing the mythmakers their glory. Earth asks,

'What am I if not observant?'
She spins on her axis, omniscient, full
of memories. She is no child, she knows
how to care for herself. She lights candles,
plays soft music, draws her bath
to rid her of these germs called us.

Earth removes a layer of atmosphere
the way a woman slips off her soft robe
from her hot dry skin.
The bath water emits steam, rises her cool blood
one single degree, and we, germ-like in behavior,
move about in fear as the ocean expands.

Just as the germs crawling on our body
did nothing to us, we too do not warrant this cleansing.
As we bathe ourselves and watch the dirt drain
down shower pipes, we forget
she can do the same. And yet it is us we blame,
disempowered and delusional. Myth makers.

Joshua Gray got the idea for "Oceans Rising" while staying at Palolem Beach in Goa. Residents said that the water has been rising over a period of several years and the width of the beach is half the length as it once was; during high tide the entire beach is underwater. Joshua lives in India with his wife and two sons.

Howard Camner

Howard Camner is the author of 17 poetry books and the autobiography Turbulence at 67 Inches. His work is in major literary archives worldwide including historical archives in the U.S. and royal libraries in Great Britain. He represents the United States in the Poet 2000 Sculpted Library in Dublin. He was nominated for Poet Laureate of Florida in 1980 and was named "Best Poet of 2007" in the New Times "Best of Miami" readers poll edition. Camner was a founding member of the Literary Outlaws and was the featured performer with the West End Poetry Troupe in New York. His new book Poems from the Mud Room is 744 pages and includes work from 1976 to 2012.

First off congratulations on your new collected poems. Seeing the range of years that this collected works took place, 1976 to 2012, it looks as if you were being published when you were a teenager. What was the first poem you published and where was it published? Please share it with us.

The first poem I ever had published was called "The Last Poem". Just like me to work backwards. The Last Poem was sort of a sensitive thing; not exactly my style these days as I got meaner and nastier with age (although sensitivity still tries to creep in when I'm sleeping). It was published in a literary journal called "Vega" out of New Jersey in 1976. The Last Poem is also the last poem included in my new collection Poems from the Mud Room which is available now all over the planet and is too big to be a stocking stuffer. Here is The Last Poem:

The Last Poem

The last poem is like the dawn of day
too young to remember
too old to forget
On occasion she soars with words as wings
On the Sabbath she rests in Parnassus' palm
In crowds she desires to be alone
Alone, she longs to know a touch

The last poem drifts through time
like a vagabond unnoticed
like a prelude to a gypsy's prayer
she twirls with eyes of twilight
ending every dark passage
with a flame of truth

She is a deathless song

The last poem is a pastoral whore of
unspeakable beauty
a contradiction of all that is
and a memorial for those of us who
understand
She is a metaphor of no translation
and a dark cloud on the horizon

The last poem is a paragon of simplicity
a portrait of a soul
and the baseborn child of solitude
Aimlessly she dances through the night
in silence
waiting for someone to take her hand
and give her voice

What's the point of writing a poem Howard? Why not a novel or even a short story?

I'm an impatient lad and I'm extremely visual. I've tried a few short stories and I'm terrible at it. I have absolutely no patience or tolerance for novels. They really upset me. If I'm in my car and a novel crosses the street in front of me, he'd better watch it. Poetry is concise and it's right there or it isn't. When it comes to me it's in flashes. I write very very fast, like a 1940s film noir reporter watching something crazy happen before his eyes or a 1950s kid watching a flying saucer land and trying to warn people. It's natural for me. When i lived in Los Angeles in the 1980s I was there to write screenplays. My poetry muse (drunk as usual) kept hounding me to put my poet hat back on. It was a bloody war which I lost. But in the end, you are who you are.

What are some of the places you recommend upcoming wanna be poets to start submitting to?

There is a little-known publication called Bristol Banner Books Anthology Series that has been around since 1877. They're out of Indiana.

I believe it's the oldest longest-lasting (Is that a word?) publication in the country. They put out anthologies in memoriam to honor obscure poets from long ago. I've been published with them since...well, it feels like since 1877, but I don't think so...a long time anyway. They are always looking for new material. An upcoming poet (or even one who's already "up") might consider submitting to them. And if they mention my name they win a new car or they'll have a better chance at getting in. One or the other. I promised myself I would never tell anyone about that publication, and I intend to keep that promise. I'm only as good as my word.

How has art come into play with your work?

Art has always been a factor in my poetry. Like I said, I'm very visual and my poems are very image-heavy (Is that a word?). That's why I really enjoy working with artists on our collaboration issues because there's a great meld. One of my dearest friends is artist Miguel Padura and we've always said that I write like he paints and he paints like I write. The difference is that he makes a fortune and I have to make a can of beans last for two weeks. But he never seems to have any money when the check comes in a restaurant. What's that about?

Write a poem about a fly on the fly and share it with us.

The Truly Amazing Unforgettable Fly on the Fly Poem Written on the Fly

A fly was on the fly 'cause she was cute in his eyes
but he saw hundreds of flies when there was just the one
Now to some, all those flies would certainly scare 'em
but to him, that one fly, was like having a harem

(damn I'm good)

How many poems do you write in a day? In a week? Do you write while on vacation?

I only write when it comes to me. I'm not one of those people who sits down in front of a blank sheet of paper and waits for lightning to strike. My muse is usually in an alley somewhere trying to make ends meet. She gets to me when she gets to me.

Eileen Tabios

The Empty Flagpoles

Why ask for asylum
in places where people seek
to leave?

Where people are not pierced
by the empty flagpoles?

Where people forget
they deliberately failed
to sign checks before they are mailed?

Where even the tiniest ant
insists on getting its bite?

Where black dresses
must be deconstructed
into ruined approaches
of increasingly unfamiliar desire?

… so tired of immolation.
Where

is the next stranger to relish
 my lips
 still painted
despite my closed eyes?

Eileen R. Tabios' most recent release is THE AWAKENING (theenk books, New York, 2013). Forthcoming is a new poetry collection, Michel's Reproductions of the Lost Flag (2014) and an essay collection on poetry and art, POST-ROMANCE (2014).

Veronica Coulston

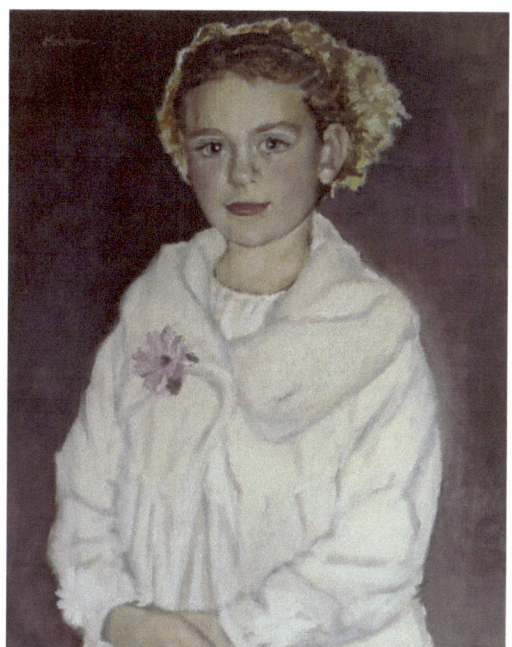
Angel Face oil 14"x18"

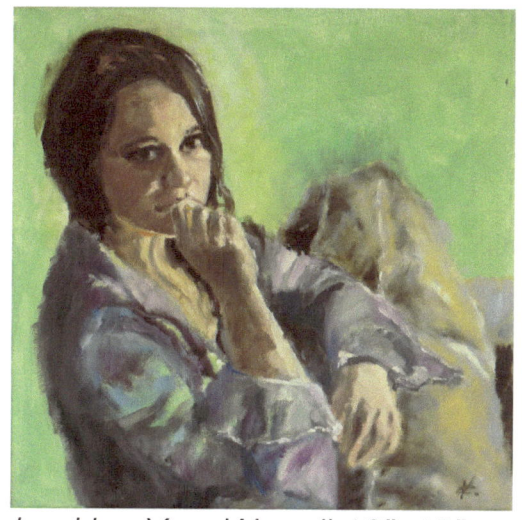
Looking Your Way oil 12"x12"

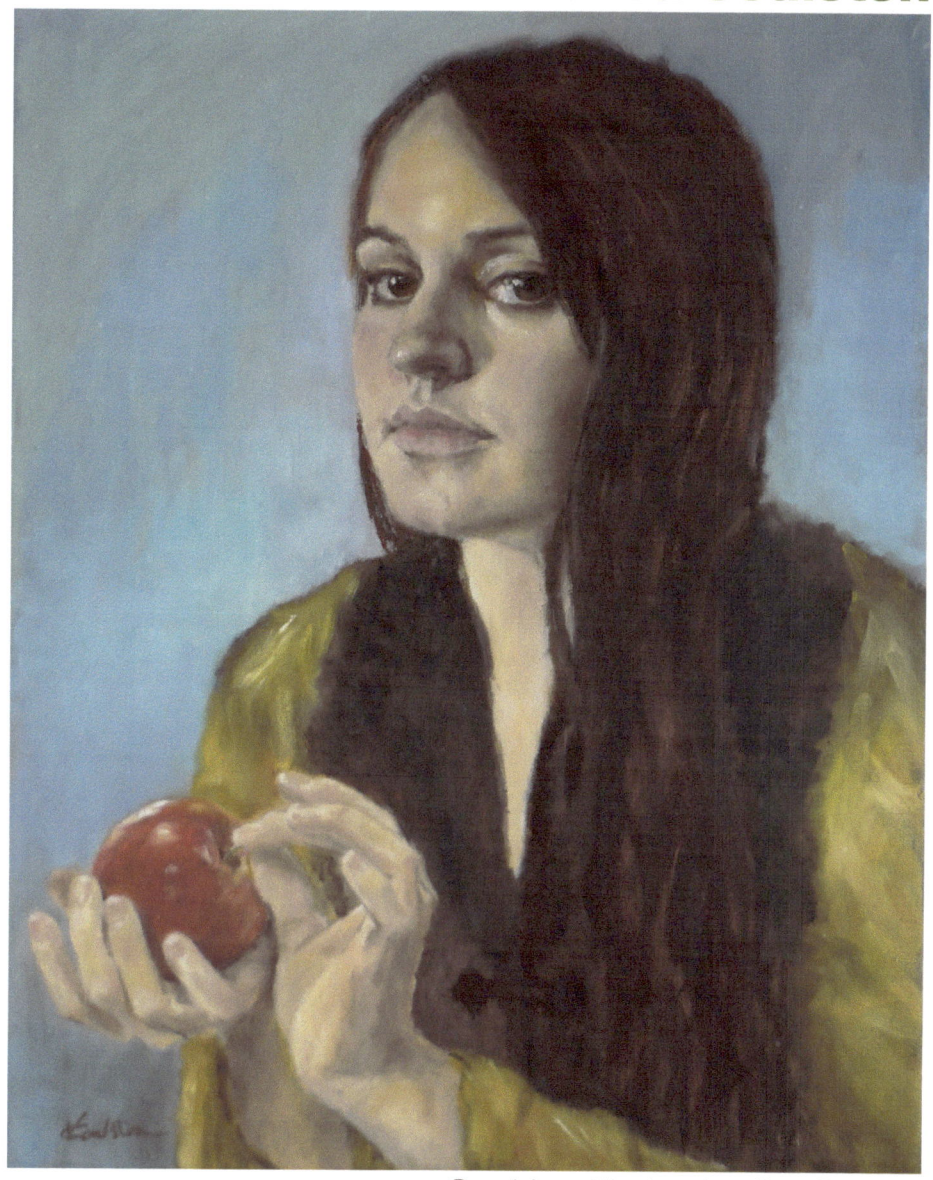
Sophie with Apple oil 14"x18"

Veronica Coulston is a self-taught artist, who grew up in Prague. She recently decided to pursue painting seriously. Her style lingers between realism and impressionism. Her portraits are soulful.

Hesther van Doornum

www.hesthervandoornum.com

Hesther van Doornum (1973) work is included in both business and private collections around the world.

People, particularly women, are a key element in her paintings. The choice of subject, expressive use of colour, composition and clearly visible strokes make her work a symbiosis of reason, feeling and symbolism.

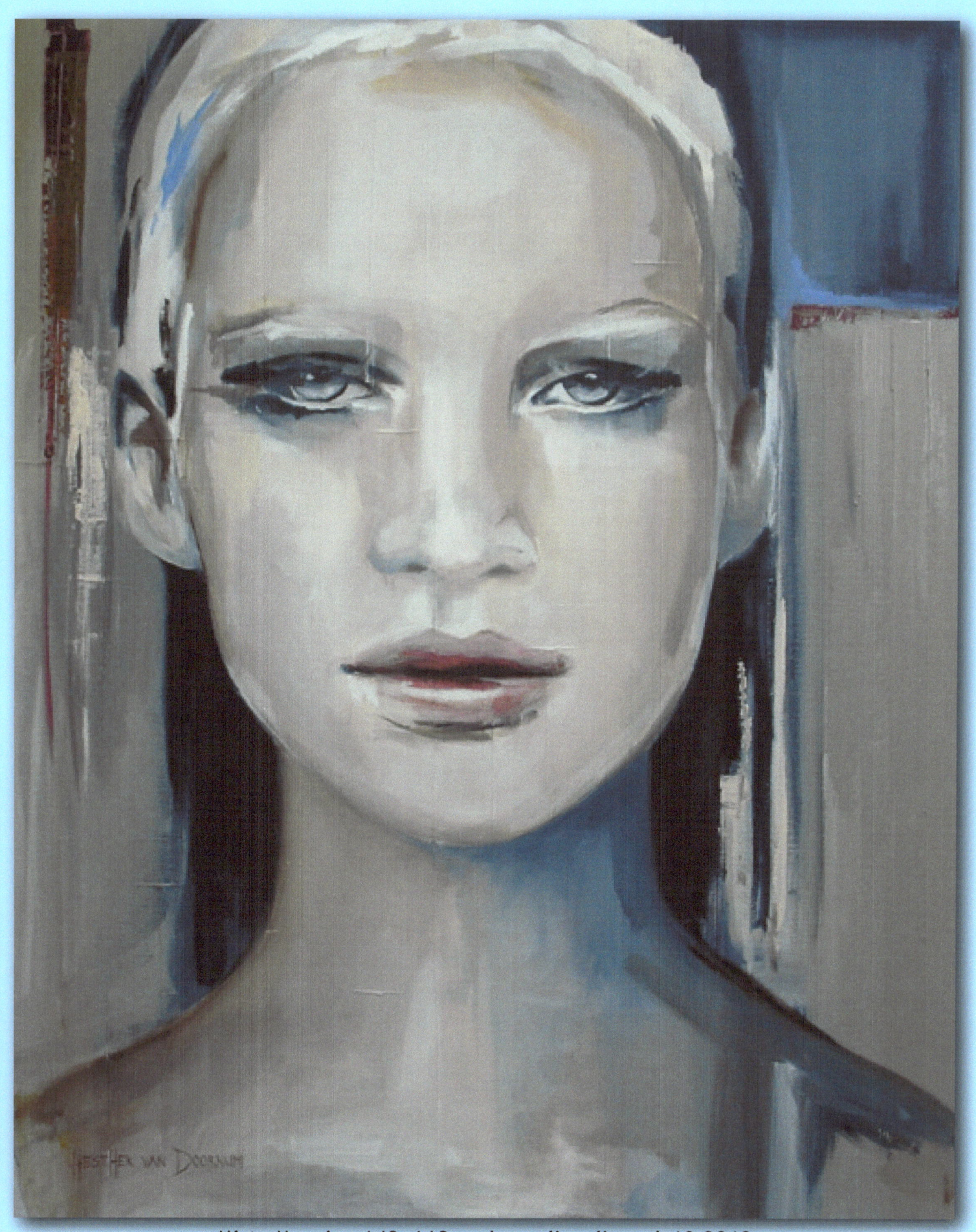

Misty Morning 140x110cm | acrylic o linen | 10-2012

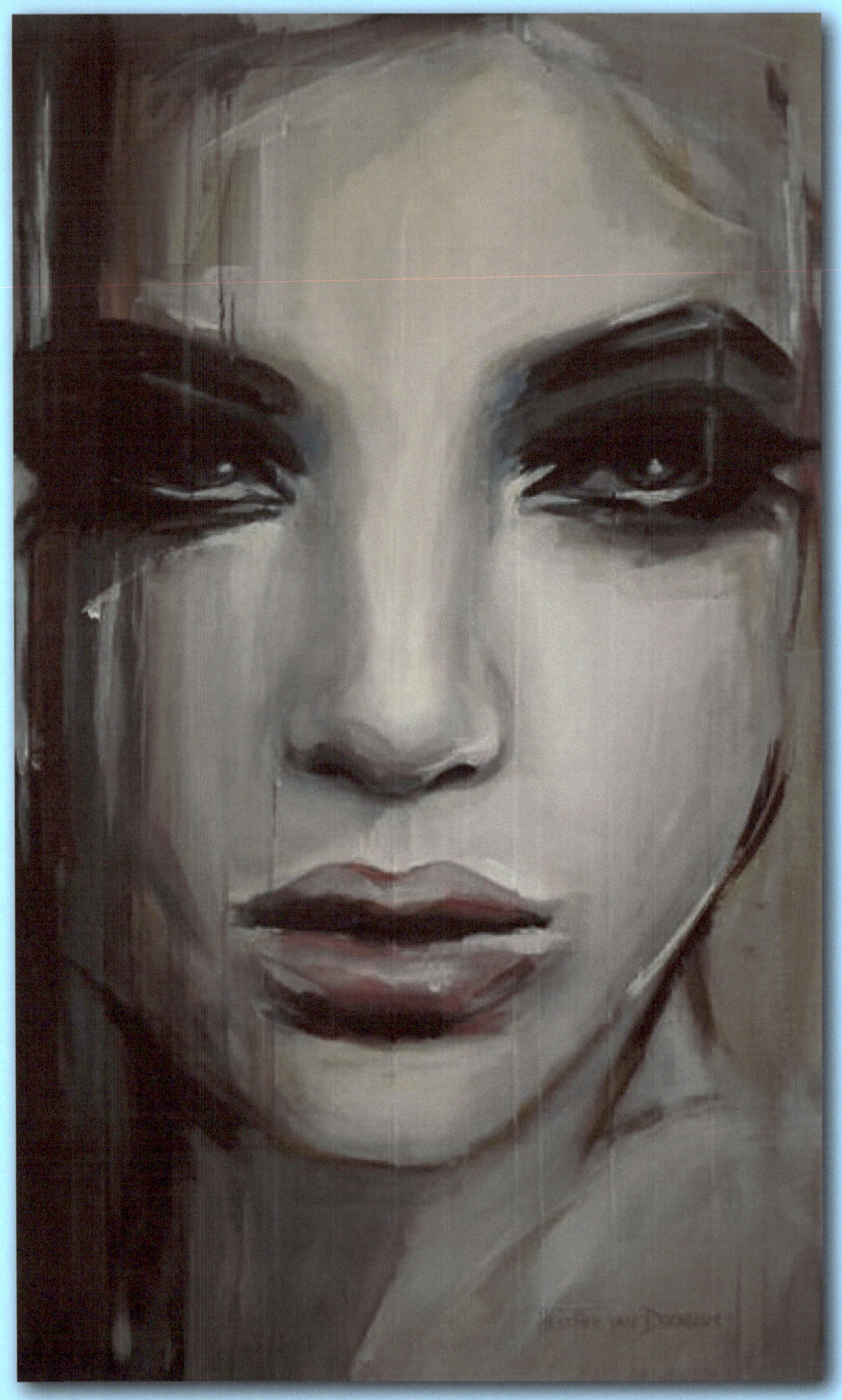

See beneath your beautiful 120x70cm | acrylic on linen | 04-2013

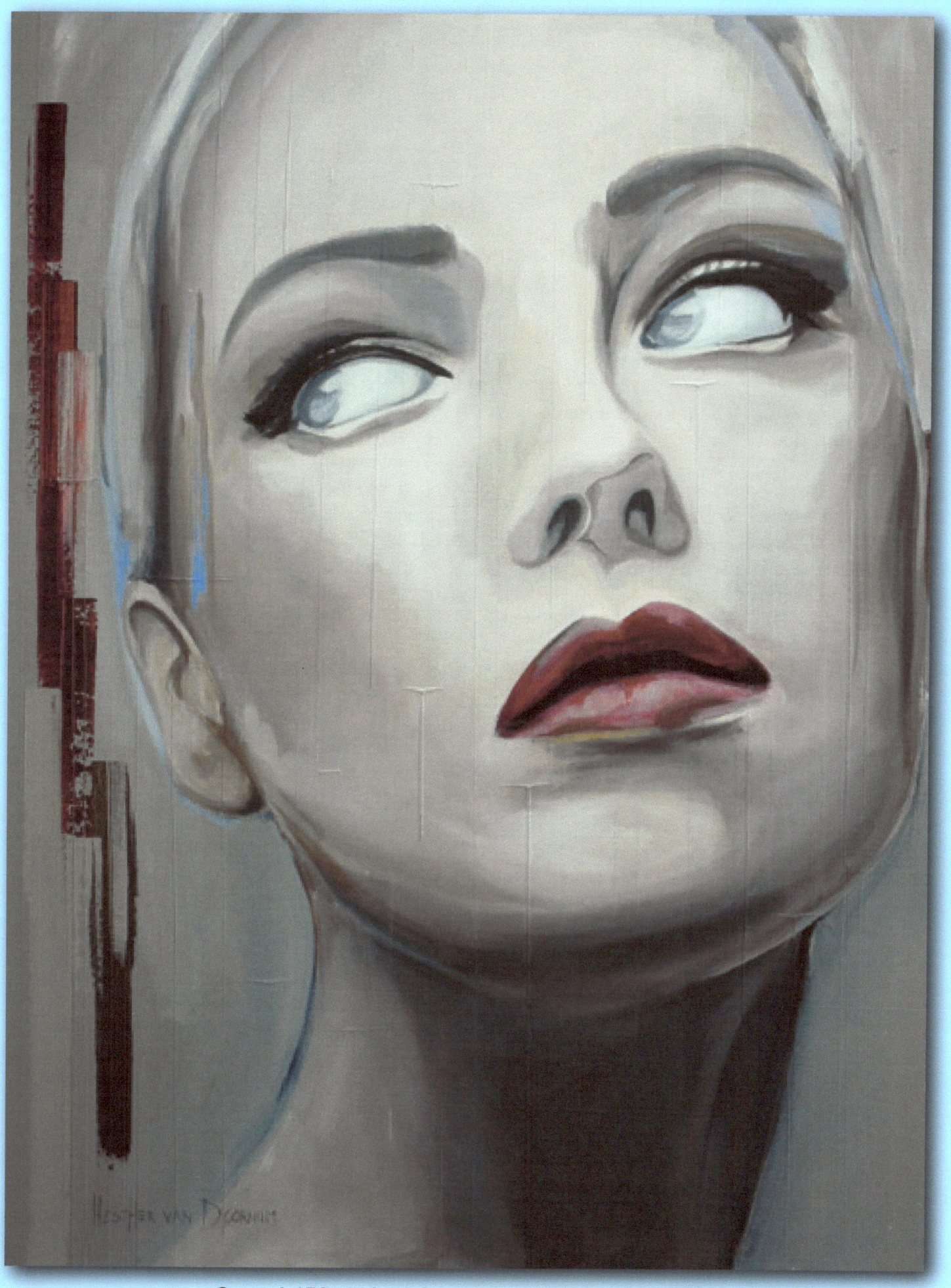

Grace I 150x110cm | acrylic on linen | 04 - 2012

Stacey Waite

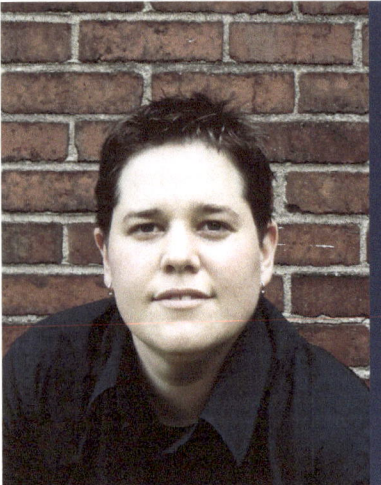

Stacey Waite is Assistant Professor of English at the University of Nebraska—Lincoln and has published four collections of poems: Choke (winner of the 2004 Frank O'Hara Prize), Love Poem to Androgyny (winner of the 2006 Main Street Rag Chapbook Competition), the lake has no saint (winner of the 2008 Snowbound Prize from Tupelo Press), and Butch Geography (Tupelo Press, 2013). Waite's poems have been published most recently in The Cream City Review, Bloom, Indiana Review, and Black Warrior Review. Waite is also the co-host of the radio podcast Air Schooner produced by Prairie Schooner and a Senior Poetry Editor for Tupelo Quarterly. For more information, visit: www.staceywaite.com.

How has living and teaching in Nebraska helped your poetry?

You know, as someone born on the east coast and then someone who lived in Pittsburgh for thirteen years, I was a little worried about the move to Nebraska—worried about living in a red state, anxious about it being so flat, so far from the water. I couldn't have known what treasures were ahead of me here in Lincoln. It's been really good for me to quiet down, and living in Lincoln has really quieted me a bit. And that quiet has been productive, especially for poetry. It also helps to be in contact with so many writers, not just the wonderful graduate students and faculty where I teach, but also the writers I talk to every month in interviews for *Air Schooner.* Getting to work in the culture of such an amazing and long-standing journal like Prairie Schooner is truly a gift—not to mention arriving here to Nebraska the same year as Kwame Dawes who is inspiring and game-changing wherever he goes.

But I would also say, about Nebraska, that there is something about those prairie winds that cut across the stand, something about those sandhill cranes that stop along the Platte river, something I could not have anticipated, something that says get moving, get writing. And that's a gift.

Your parents seem to be a major influence in your work. Has poetry ever served as a therapeutic remedy?

Well, as the kids I coach for poetry slams like to say about our team: we all got Daddy issues. And I'm not exception. This is an interesting question because I think a lot of poets are nervous about openly discussing autobiography and their work, but I'm definitely aware of how much our origins, or sometimes lack of origins, (however we define or think about them) show up again and again in our work. My biological father wasn't really a fan of me: of my gender expression, my assertiveness, or my crafty dodging of his attempts control those things. And I think I've spent a large part of my life trying to write my way through that relationship. He died in 1999, right after I graduated college and we never really got to work things out. Not really sure it would have been possible. But there's a way in which many of my poems are prayers or letters to him, ways of speaking back to his voice, which is also the voice of normative structures everywhere.

I wouldn't call poetry a therapeutic remedy, per se (it's more like a survival strategy) but I would say that the kind of writing I really love to read (and therefore the kind I try to write) is work with something at stake for the writer. When that sense isn't there, it just feels like all craft and no heart. I think poems ought to have beating, bleeding hearts.

When did poetry first creep into your life?

I started writing really young. I remember, as a kid, and as the youngest of my siblings, being really impatient about learning to write. I wanted to be able to do it before I could do it. Sometimes I would sit in my room and write what looked like letters on paper and I would come to my mother and say, "I wrote something." And she'd be all dutiful and say, "That's great," even though what I had written amounted to nothing. Actually when I finally learned to write words, I had a bad habit of (and this was before erasable markers) labeling everything in my room—writing "table" on the table and "lamp" on the lamp. I was obsessed with being able to write down the names of things. When I knew relatives were coming over, I'd write down all their names and put little cards on the dinner table. It's funny to me now especially since I've learned to trouble the naming process and since the idea of naming (of knowing something through language) is something I think of now as beautifully, terribly, impossible.

Poems themselves were also an early fascination. I wrote a lot of terrible rhyming poems and some teenage angst poems later on. I have several boxes of those what we called "salt and pepper" composition notebooks from those years filled with three types of poems: the my-father-doesn't-love-me poem, the this-girl-doesn't-know-I-love-her poem, and the gender-isn't-fair-poem. And, as it turns out, I'm still writing (I hope more complicated) versions of those poems.

Tell us about your new book.

Butch Geography, which came out just this year with Tupelo Press, feels like the book I've wanted to write my whole life. Some days it's difficult to imagine what to do next. The poems in the book are largely autobiographical, yes (which doesn't mean they are all about events that have happened; it just mean they are all true). But I think of the book more as a study of gender, a meditation on what gender means or how it works. It's an elegy for the body or for the body we think we have, or reflect, or represent. Because poetry is a place where contradiction and tension are welcome and celebrated, it's not a surprise to me that I would turn to poetry as a way to understand or reflect gender. The title has been with me for many years, and I do think of identity as a kind of geography, a space we move through or sometimes stay in longer than we think. It's funny, some people who gave me feedback on the manuscript worried that the term "butch" was too out of date or too aggressive, but there was really no moving me on the title. The term "butch" was there for all of us old-time he-she's who had no names for ourselves, and while I've come to think of myself with many other different names for my expression of gender, that term seems part of an important origin for me and for lots of queerly gendered folks, I think.

Whose poetry have you been reading lately and what do you think about it?

Some highlights of my reading these past months have been Aaron Smith's book Appetite, which I think is urgent, and honest, and a truly nuanced collection that chronicles gender and the body. Yona Harvey's new book, Hemming the Water, is stunning and some of the most simultaneously innovative and deeply political work I've seen in a long time. And of course, Denise Duhamel's Blowout was released this year. I've been inspired by Denise Duhamel since Girl Soldier—her playfulness, her fearlessness, and her narrative radiance just gets me every time. Denise embodies a wonderful quality that my step-father (who is really the only father I've ever known) also has: that sense of both taking something seriously and not taking something seriously all at the same time. Some poets could really use that lesson, I think. I think knowing that poetry is serious and that poetry isn't serious—knowing both of those truths—means really getting it, and then hopefully writing poems that get it. I should also mention that Troubling the Line: Trans and Genderqueer Poetry and Poetics, a book edited by TC Tolbert and Tim Trace Peterson, was just released from Nightboat Books this year. It's a beautiful collection, and quite a big collection that I was proud to be part of. I've been reading through the poets in that book quite a bit this year.

How often do you submit work and are there any specific venues (journals, web sites, magazines) you prefer to submit to?

I usually submit work four or five times every year. I'm not as quick with sending out poems these past two years as I once was. I am working on an experimental book of scholarship called Teaching Queer, and that's been taking up a lot of my time. But some of the publications I return to again and again are *Bloom, Knockout, The Rattling Wall*, and I am just crazy excited about *Tupelo Quarterly's* first issue coming out this year. I'm delighted to be one of the Senior Poetry Editor's for that publication. I'm also psyched that the journal *HeArt Quarterly* is coming back this year!

What are some of your favorite poetry reading moments of all time?

First of all, I love poetry readings, good ones. I love poetry slams, good ones. And there a few reading moments I'll never forget:

Hearing Galway Kinnell reading "The Bear" at the Carnegie Museum in Pittsburgh. He sort of reads it like an actual bear! Brian Turner gave a reading this year at UNL that I watched changed some students' lives. You want to hear someone read whose voice really embodies the work, get to a Brian Turner reading. Last one, though I have more. Once my good friend Brandon Som (a talented and beautifully lyric poet whose book is coming out in 2014) and I each got to read a poem (back in graduate school) to "open" for Sonia Sanchez. She asked us to, which was amazing and terrifying. And then she sang and read poems and in a room of 300 people, hardly anyone breathed.

No City

Give me a minute.
I am waiting here
for you to gesture.

Now the flooding of gutters
the tomb of lights
swelling up through
the windows melting
you've been at the edge
of no city you've
left an echo of pulse
beneath our bed
our bodies are only
the beginning.

www.ingramcontent.com/pod-product-compliance
Lightning Source LLC
Chambersburg PA
CBHW050809180526
45159CB00004B/1602